C000162867

Clayton Anderson

KICKING SAWDUST

Running Away with the Circus and Carnival

Daylight

Cofounders: Taj Forer and Michael Itkoff
Creative Director: Ursula Damm
Copy Editor: Gabrielle Fastman

© 2020 Daylight Community Arts Foundation

Photographs © 1988–1991 by Clayton Anderson

Foreword © 2020 by Katharine Kavanagh
Introduction © 2020 by Jack Pierson

ISBN: 978-1-942084-92-1

Printed by Artron, China

Daylight Books
E-mail: info@daylightbooks.org
Web: www.daylightbooks.org

For Deborah, Keith, and Todd

Foreword

The collection of photographs in this book stands out from other publications because it focuses on the real lived experiences of Clayton Anderson and his traveling family at the end of the twentieth century. It doesn't try to paint a nostalgic fantasy, or conjure romantic myths of escapism and otherness, but captures instead the true human heart and day-to-day work of the showman's life, in an era that is often overlooked in the grand narratives of circus and fairground entertainment.

Browse specialist bookshops, or search online, and it's pretty easy to find publications that document this lifestyle at the *beginning* of the twentieth century. However, the rapid development of other entertainment forms as the century progressed removed traveling circus, fairground, and sideshow from the forefront of people's imaginations. The prominence of new entertainment media and the backgrounding of traveling showfolk in the experience of public life, in turn, led to misconceptions that the traveling art forms were dying. In fact, they were doing what they always have—adapting and evolving. Within the smaller touring circuit of the United Kingdom, for example, the worlds of circus and fairground remained much more separated, and sideshow—when it appeared—was associated more with the fair than the circus. Seeing all three elements brought together in this book brings a sense of the magical universe that the combined shows of the United States created for their audiences in the last millennium. Nowadays, we can see sideshow at Coney Island or from specialist cabaret performers; we can visit fairground attractions at year-round theme parks; and we can see circus in theaters, on

television, and on YouTube, as well as in touring tents. What these experiences don't give us is the sense of camaraderie and community life that the combined shows fostered, and that the photos in this book recollect. Now, in the twenty-first century, it's more common for the photo collections I come across to illustrate cutting-edge developments in the technical aspects of performance—skills, costumes, settings—rather than a wider representation of the touring lifestyle. I think it's vital that people who still choose to work in the classical touring mode of spectacle and entertainment are represented in contemporary publications and not hidden away as if to be forgotten. Clayton's evocative collection does just this.

While the history of traveling entertainers and itinerant performers dates back to time immemorial, the story of combined shows can be traced through just the last three hundred years. The modern circus form of the Global North was established in London, England, by ex-cavalryman Philip Astley and his wife, Patty. The pair began selling tickets to horseback entertainment in 1768, soon adding clowning, acrobatics, and other animals—such as Patty's famous "lady's muff" of bees. The mixed program was a swift success and, while Philip went on to launch amphitheaters in other European cities to present similar programs, two of his rivals in London went on to coin the word "circus" to describe the events. By 1793, the circus form had arrived in America courtesy of John Bill Ricketts, an Englishman who had worked in circus establishments in London, then in Scotland, before crossing the Atlantic to introduce the form to a new continent. Within a few decades, America

was shipping innovations of its own back to Europe, in particular the idea of traveling under a canvas tent instead of pitching temporary wooden buildings or open-air arenas. The industrial revolution in the nineteenth century generated a massive expansion of railroads and this allowed showfolk to travel with larger enterprises across greater distances. Over the expanses of American soil, different varieties of traveling entertainment were coming together under single entrepreneurial banners to form vast moving cities of circus acts, sideshow presentations, animal menageries, and, later, fairground rides, catering to guests with concessions of food, drinks, and confections, alongside the other diversions.

In contrast to the European tradition, led by performing families and focused on the artistry in the ring, circus historian Dominique Jando comments on the particular character of American circuses as a combination of entertainments "run by businessmen." The most famous of these is undoubtedly the Ringling Brothers Barnum and Bailey enterprise, which traced its lineage from Phineas T. Barnum's later life venture of "P.T. Barnum's Great Traveling Museum, Menagerie, Caravan, and Hippodrome," launched when the exhibitor was persuaded out of retirement in 1771 at the age of 60. Ten years later, that show merged with James A. Bailey's well established circus to become the Barnum and Bailey "Greatest Show on Earth." In 1907, the Ringling Brothers conglomerate purchased the show, and another merger with their own circus in 1919 created the moniker that took the iconic enterprise up until its closure in 2017, 146 years from its ostensible beginnings. Smaller showfolk

businesses have also grown up and thrived across the world though, and in the United States, these have been characterized by their multitudinous leisure offerings.

The standard setup of a show traditionally included separate regions for the different entertainments over time: the big top for the circus show, the midway for sideshows and stalls, the menagerie for the animals, the fairground for the thrill rides. Sometimes a "cooch tent" for titillating adult performance, or a restaurant for more upper-class refreshment. The experience of attending one of these combined shows, however, was enriched by being able to wander among and through these different diversions in one wonderful, here-today-gone-tomorrow world of variety and surprise. In this book, Clayton Anderson has combined his photos to give the reader a similar experience. The elements of circus, sideshow, and fairground are not separated into distinct sections, but blend together to give you a sense of wandering through this world as if taking your own trip back there. While artists and other show workers often have clear identities based on their roles, for audience members it has often been more difficult to know where circus ends and carnival begins, or where sideshow and fairground divulge from one another. In part, this is why circus is so hard to define for contemporary audiences; perhaps the definition should include this shifting pattern of pieces. While most modern publications try to separate, dissect, and determine the various forms, it's a joy to find this book that celebrates the intermingling and blurred edges of the audience experience.

Of course, even in the last thirty years, public attitudes and tastes have shifted with the changing times and the photos taken at the end of the twentieth century capture a particular era. While showfolk still travel and provide a variety of entertainment for local populations around the world, certain styles of presentation captured in these photos have fallen out of favor. Long overdue public debates around disability rights, animal rights, racial representation, and troublesome gender norms influence the way we look back on some of these images today. While it might at first seem natural to tut and look disapprovingly at scenes that sit awkwardly with modern sensibilities, it's perhaps more productive to consider the complexity of the different societal forces at work. Does inviting people to gaze at your difference perpetuate a distancing and dehumanizing effect? Or is there agency in choosing a career path and a lifestyle that allow a level of social prestige, respect, or privilege ruled out by other possibilities? Naturally, these are questions too big to be answered with one-size-fits-all glibness in this short introduction. What's valuable, however, is recognition of the different—and often conflicting— perspectives. This book offers us a portrait of the life Clayton, his colleagues, and family experienced on the road, but the big picture is formed by the many individual portraits it contains. There were no doubt struggles, and no doubt high times and enjoyment too, as for all of us in any walk of life. I hope this book sparks more than nostalgia or voyeurism, and opens up new ways of considering the vibrant and vital lives of traveling show people who still earn their livings giving the rest of us pleasure.

—Katharine Kavanagh
Cardiff University, School of English,
Communication, and Philosophy

Introduction

Clayton literally was the boy next door when I met him. My friend André Laroche and I wound up taking a room at the David Court on First Street and Washington Avenue on Miami Beach in the first week of January 1984. The rent for our room was fifty-five dollars a week. Clayton's room, being slightly larger and possessed of a window from which one could see the ocean, was seventy-five. He was doing better than the two of us put together, as the fifty-five for the first week was the last of our money. André secured employment as a busboy at Joe's Stone Crab though, so we weren't too worried. He made some cash tips and got to bring home an abundance of dinner rolls, which were quite good.

We didn't interact with Clayton right away. We saw him rather hurriedly go by our place on occasion, because we kept the door open, so enchanting was the ocean breeze and the idea of having a door that opened to the outside. He told me later that he thought we were weirdos. I couldn't disagree. In any case, after we all let our guard down—I think we called out to him going by at some point—we became fast friends, as only the young can do. Clayton, I think, was 19 at the time, and I was 24. The five or six months we spent at the David Court were, as they say, formative, at the very least for me. It would take a while to explain why, and wind up being mostly about me, which is always a distinct possibility that I try to circumvent. I'm going to assume those days were meaningful for Clayton too, as he's asked me to contribute to this handsome book of his photographs. I'm not here to interpret the work. You will easily see why it's important and being afforded this presentation.

I believe our hero Clayton wants this simple story told: At the end of a few months, and the beginning of summer, André and I were making plans to return to New York City. The saddest part for me was leaving my new best friend Clayton. The saddest part for Clayton, who had been working as a waiter in a semi-classy place in Coconut Grove and living the life of a fancy-free beach boy for about a year, was that his dad had called him on the payphone in the courtyard of our beach-adjacent SRO and asked that he come help his family by working a cinnamon roll concession his father operated in a traveling carnival.

Clayton couldn't believe his misfortune. I couldn't believe his luck! What an opportunity! As an art school dropout in search of "my voice," I was envious of the classic subject matter that seemed to have spilled into this kid's lap. Clayton at that time didn't have artistic aspirations. They weren't something he had thought of for himself. Regardless, I told him emphatically that here was a situation that required a camera and for him to use it. A traveling carnival for chrissake! He'd be an actual carny! Here was a glorious possibility! He could almost not go wrong. Buy a camera and *please* take pictures.

I'm great at ideas for other people and my new friend was the first to ever take one. And now that I'm thinking, quite possibly the last. There it is then. This book is the gift he brought back nigh thirty-seven years ago from some of the last days such an evocative world existed. A world you could kick some sawdust in. I could not be prouder of these pictures if they were my own. It is one of the great joys of my life to introduce Clayton Anderson and his masterful photographs to you.

—Jack Pierson
New York City, April 2020

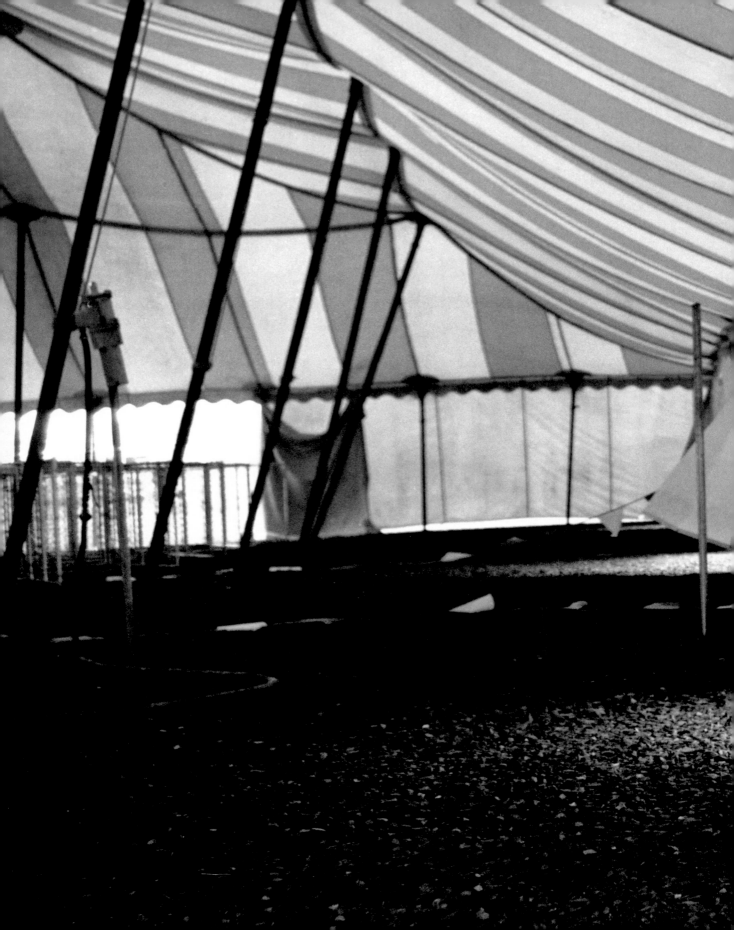

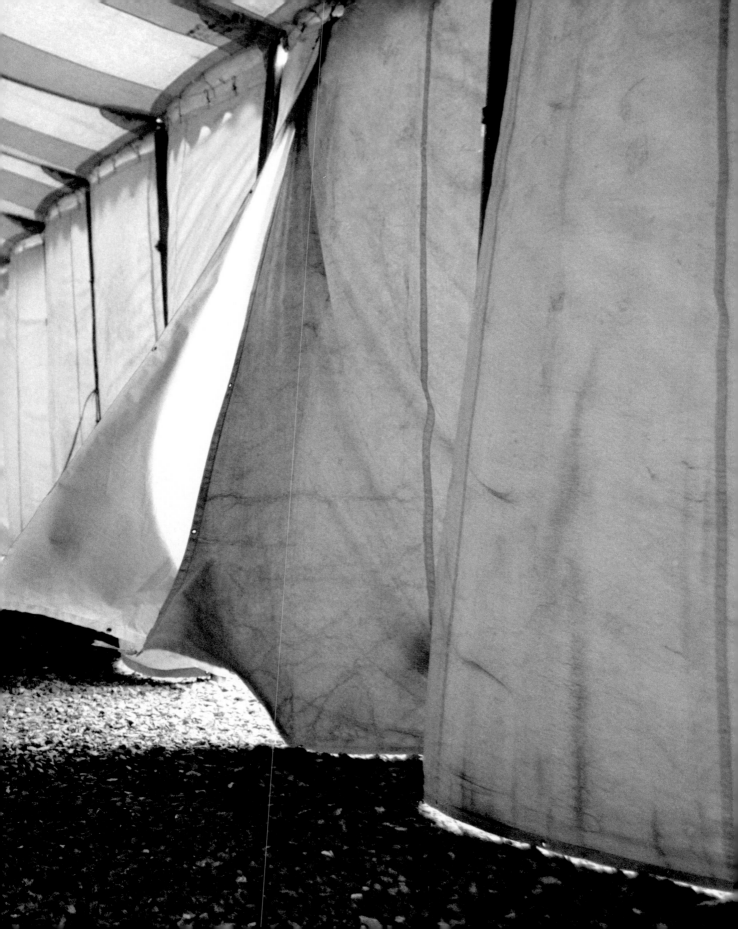

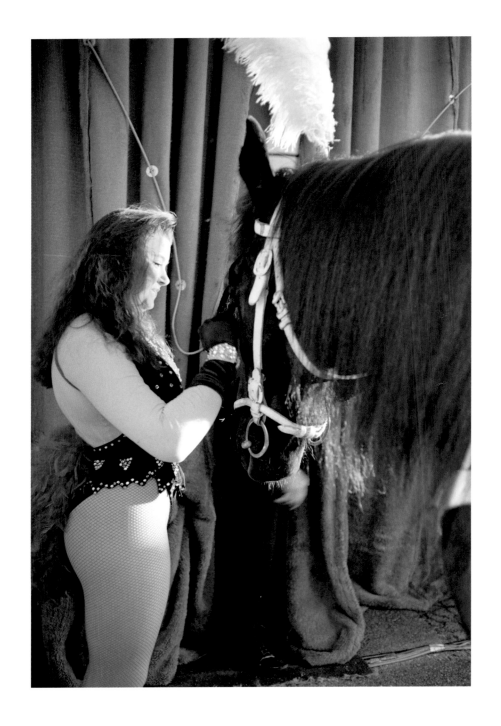

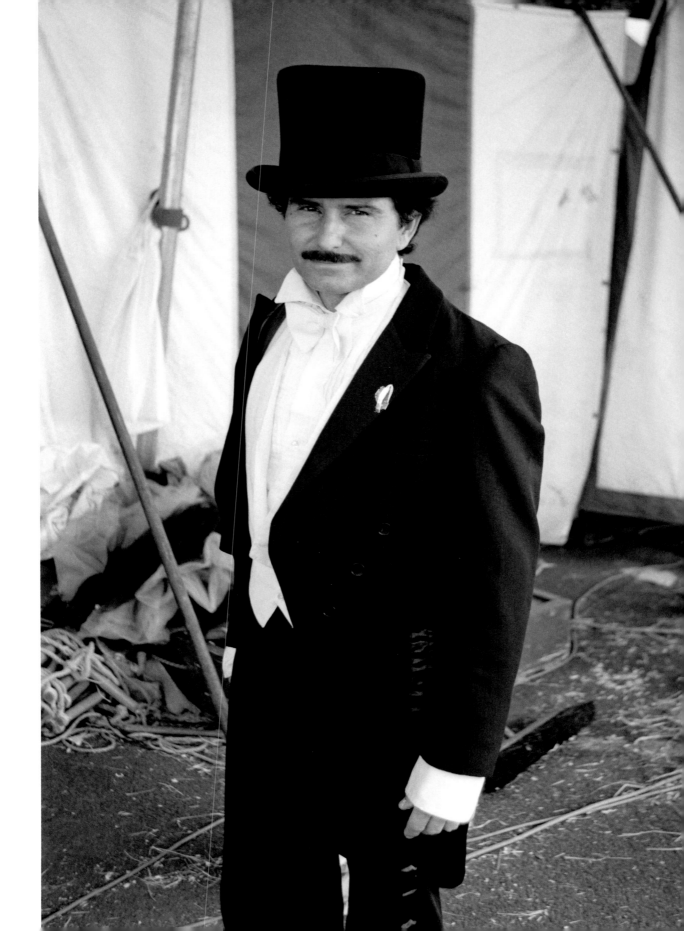

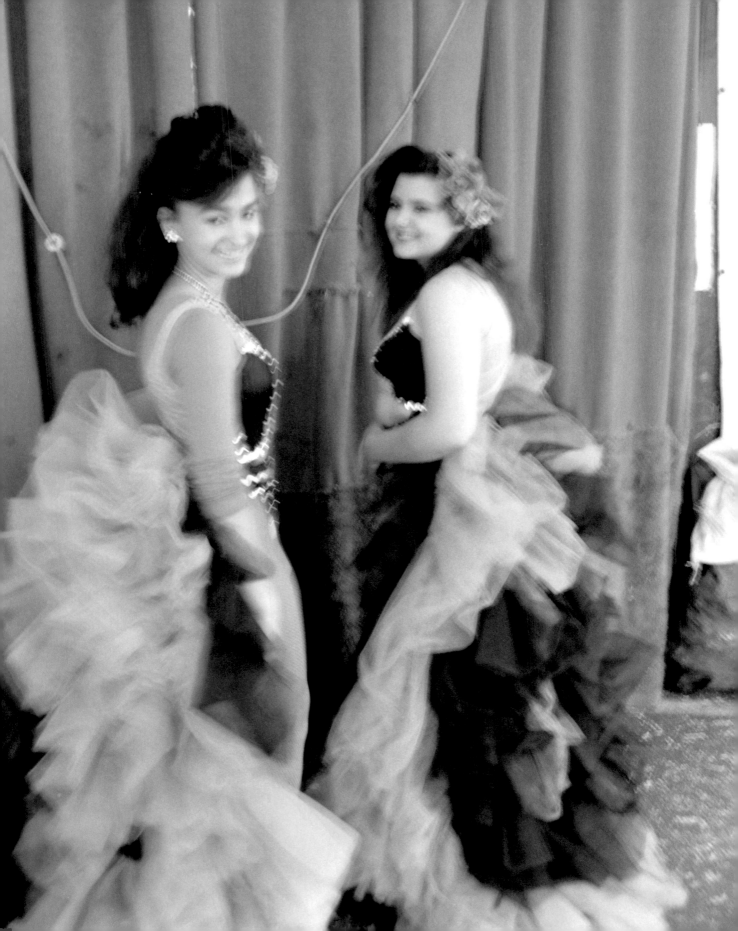

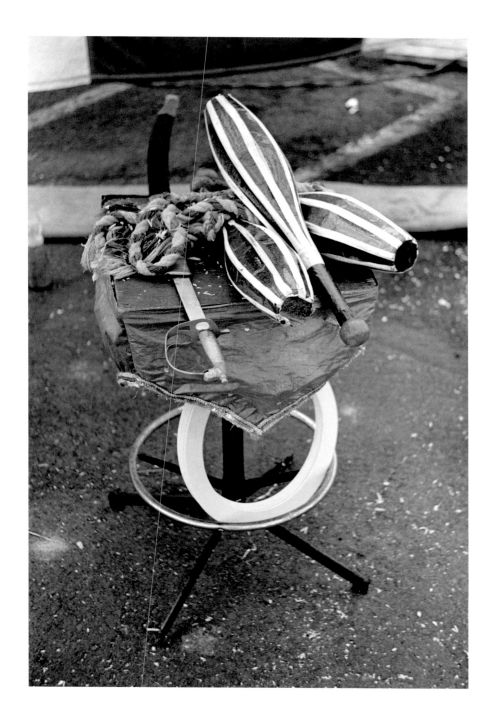

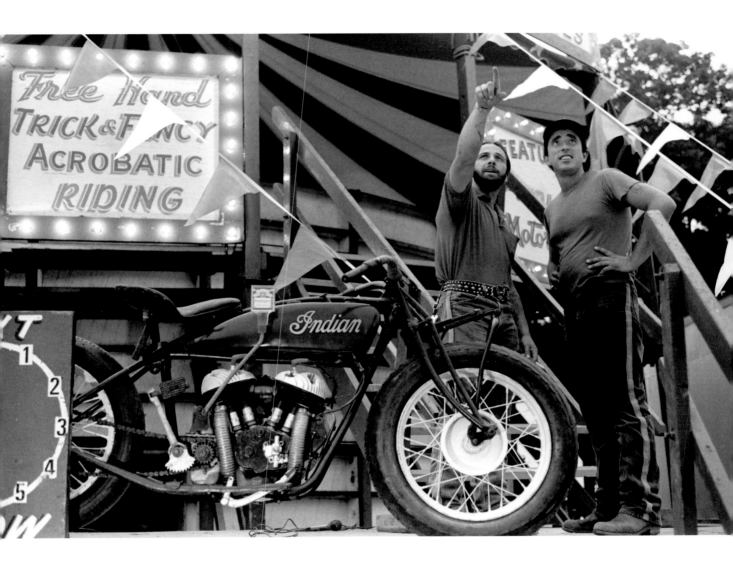

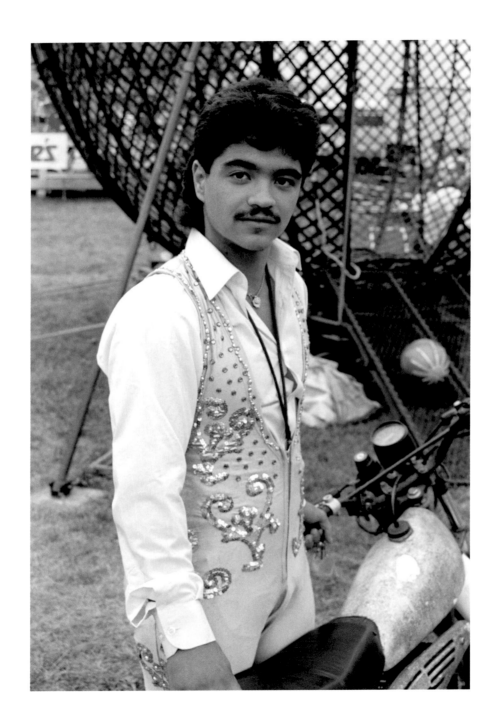

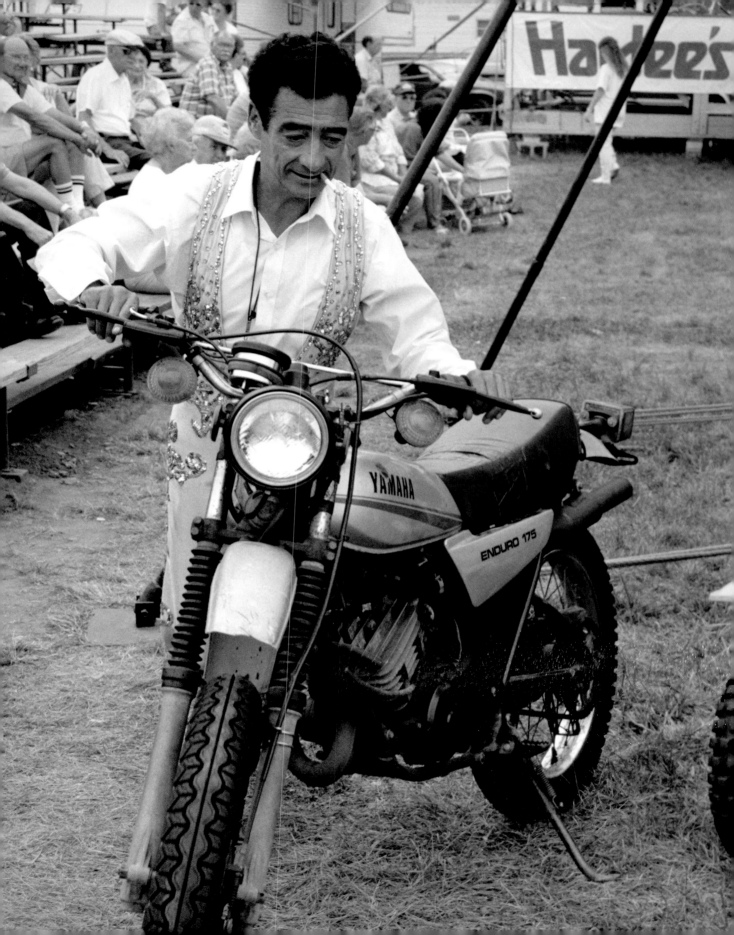

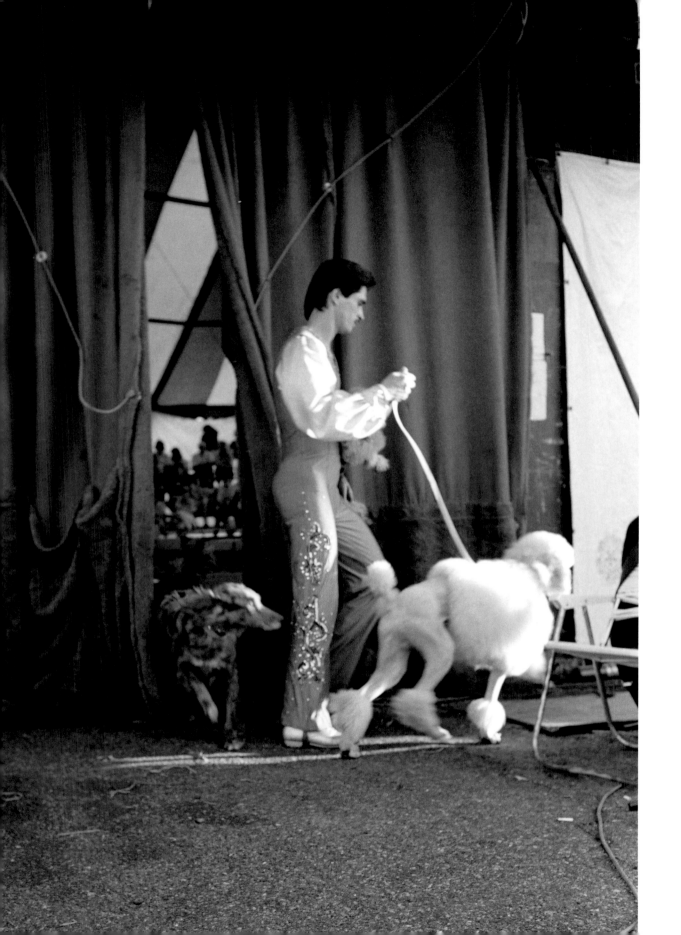

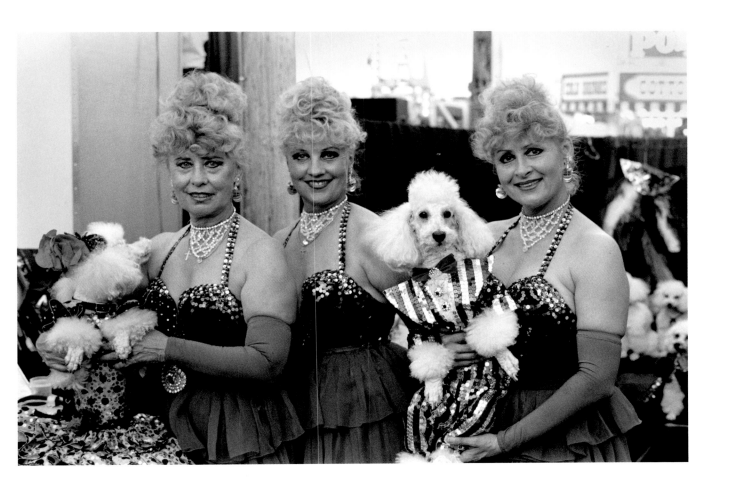

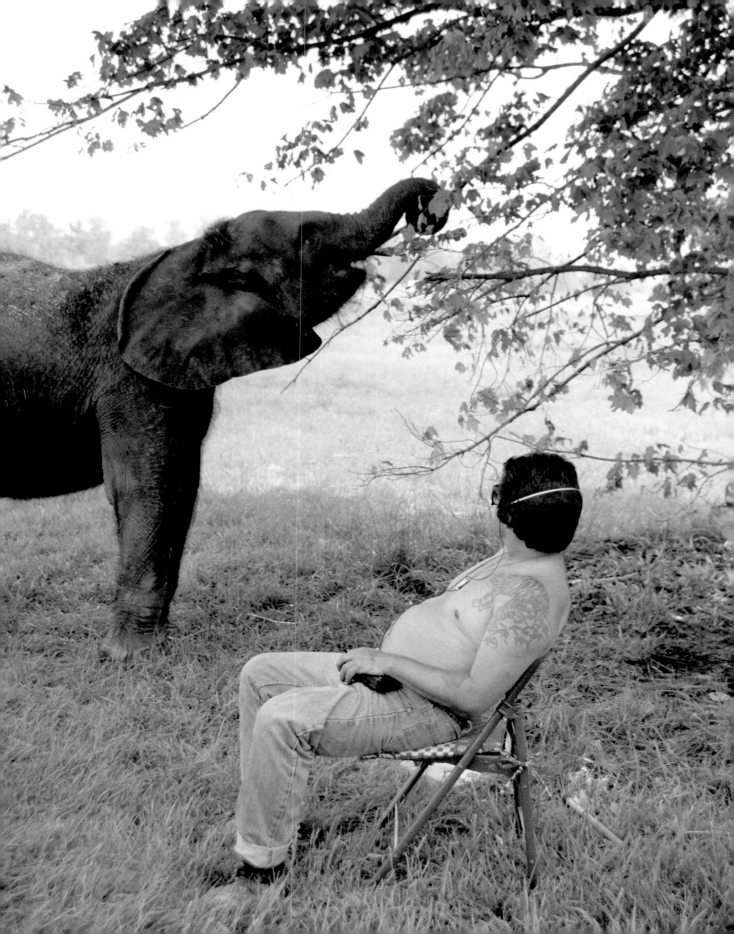

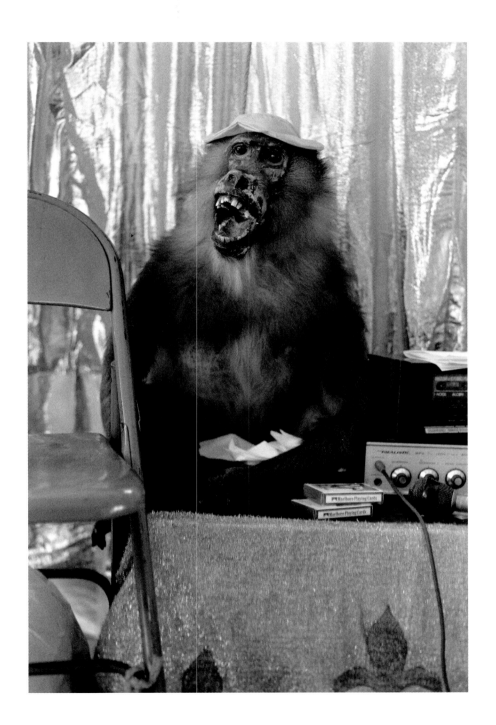

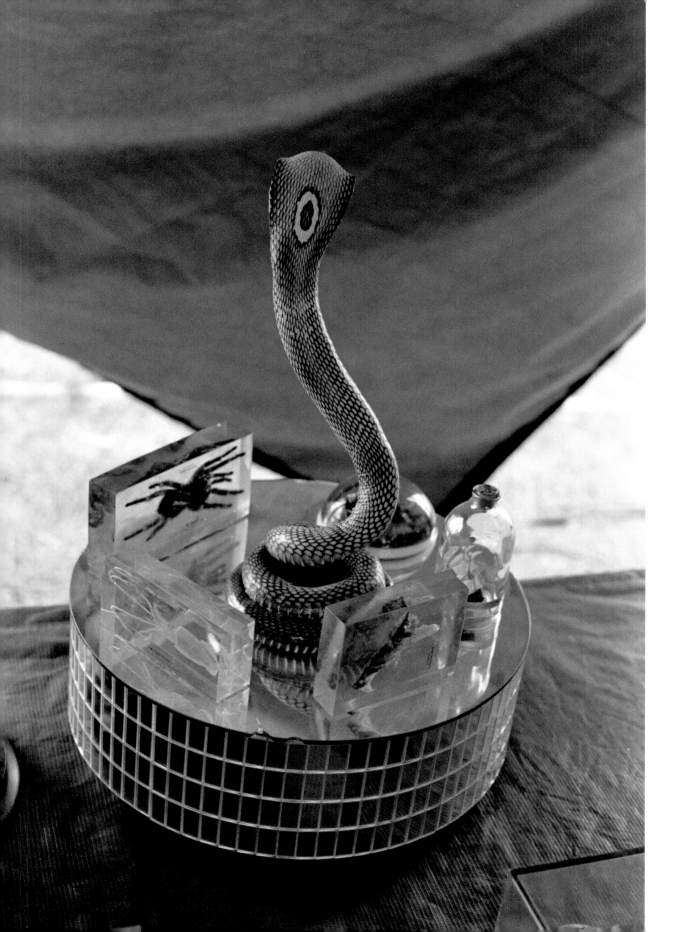

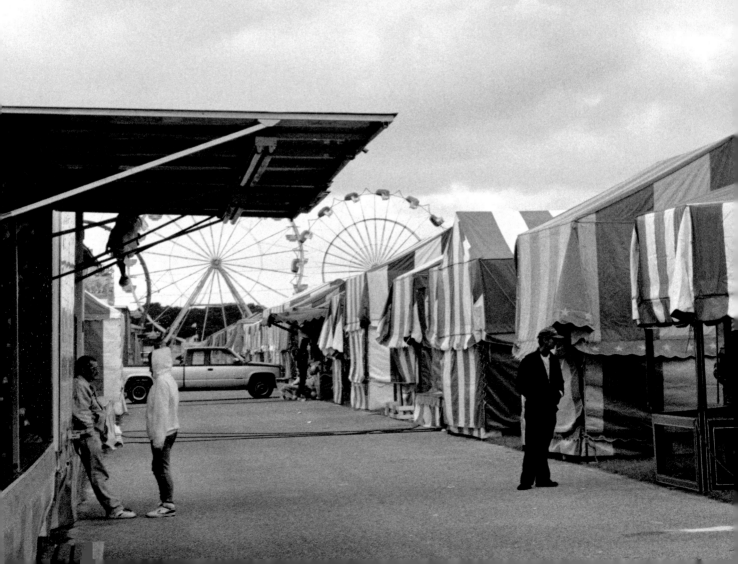

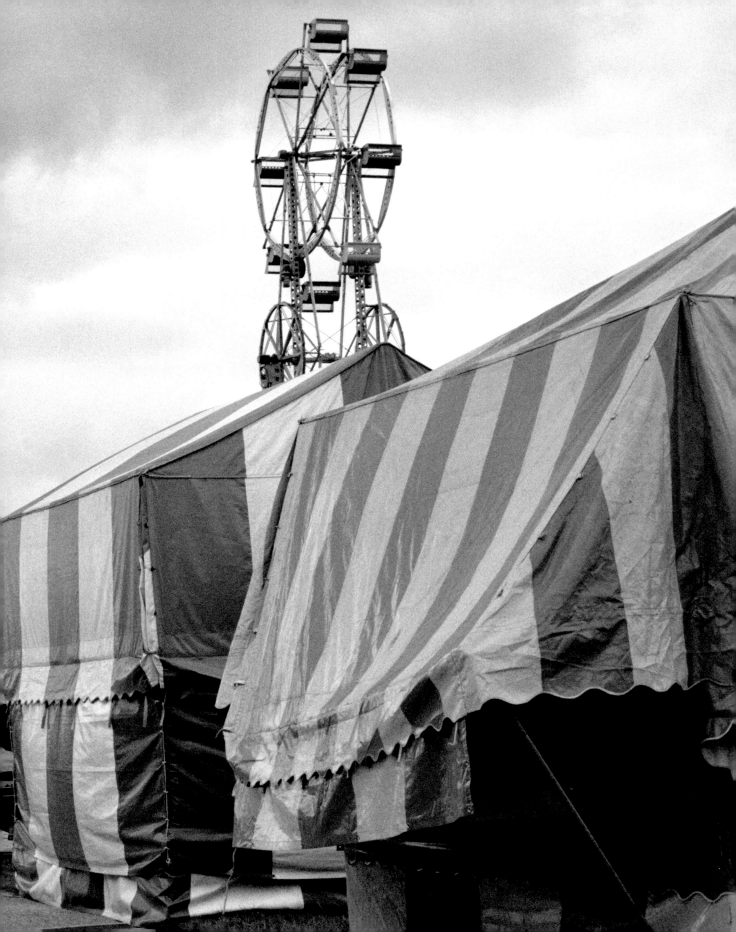

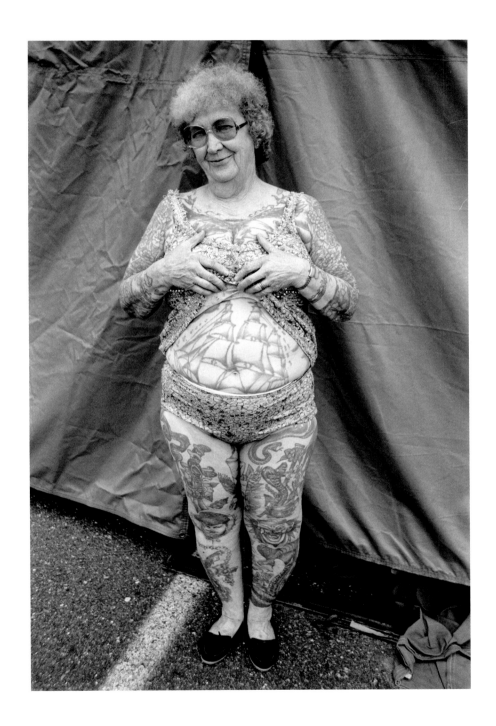

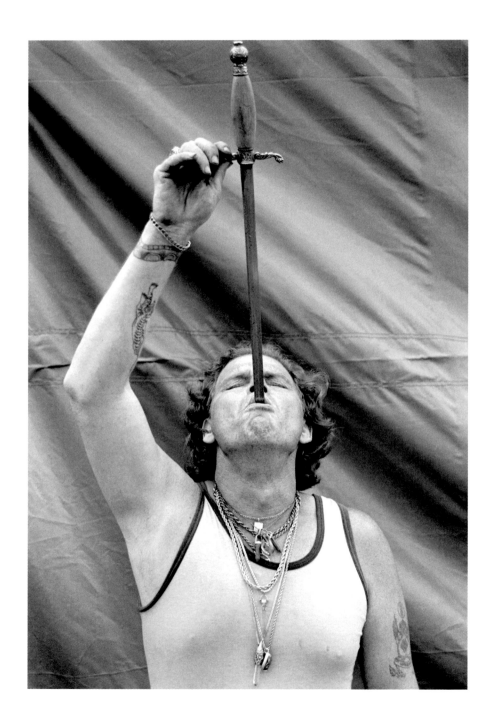

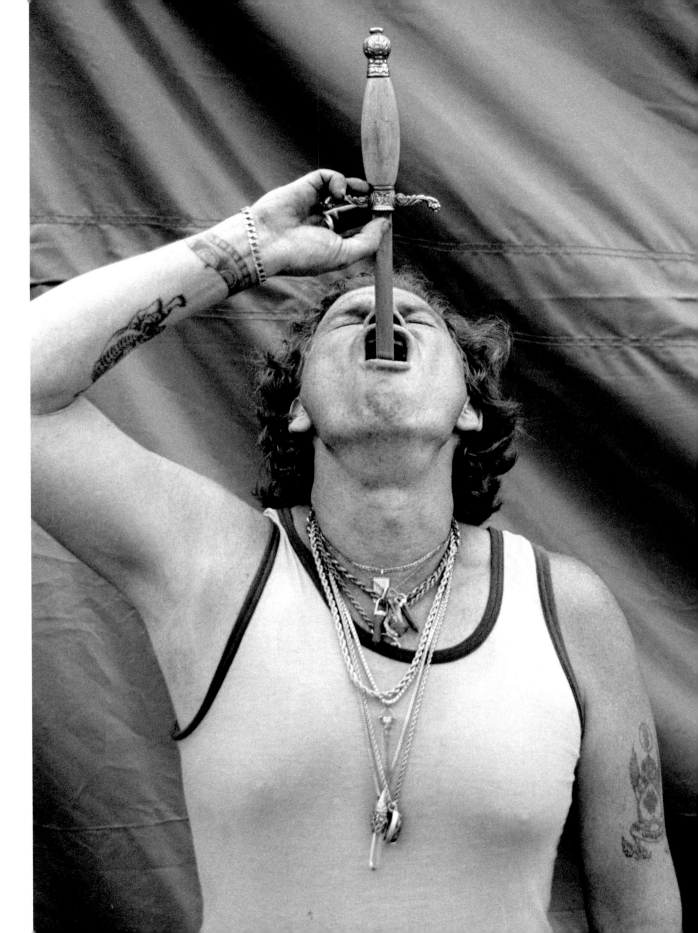

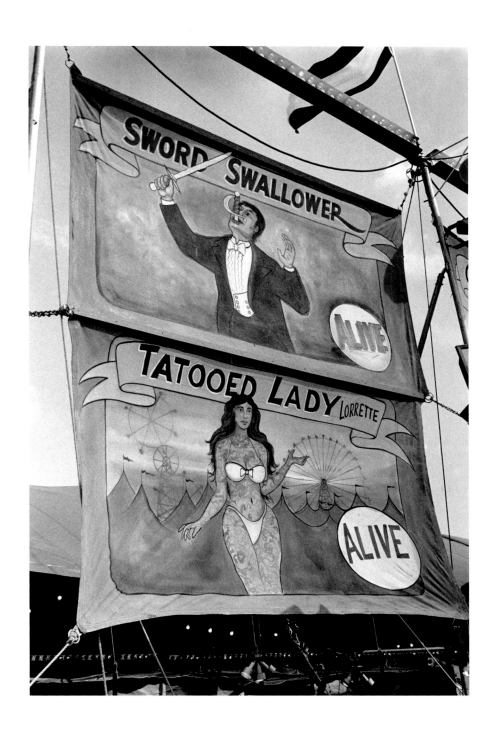

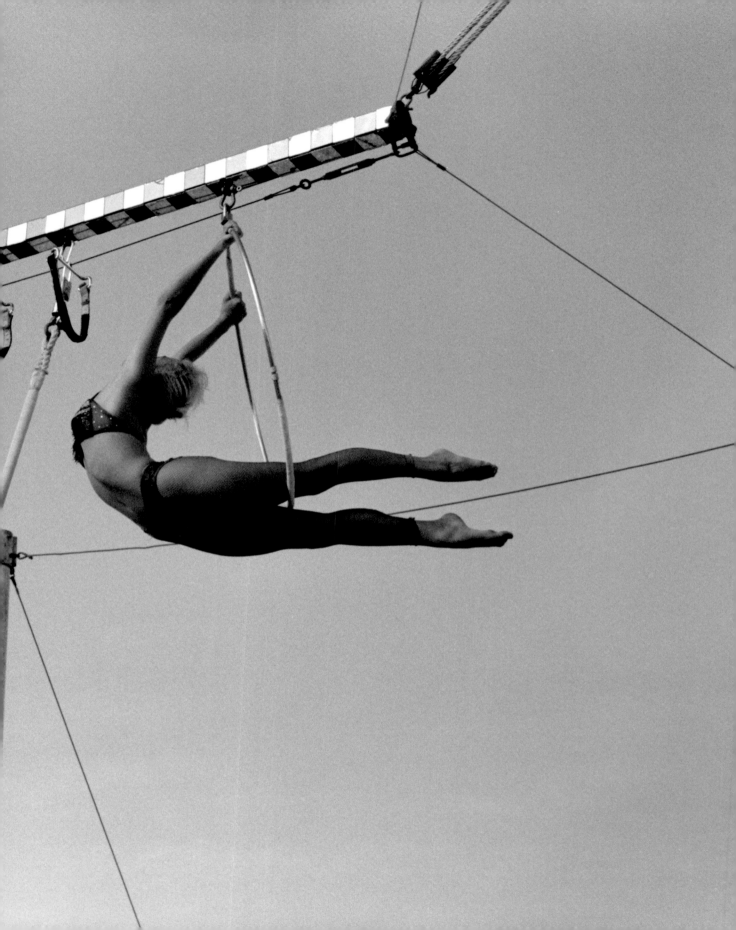

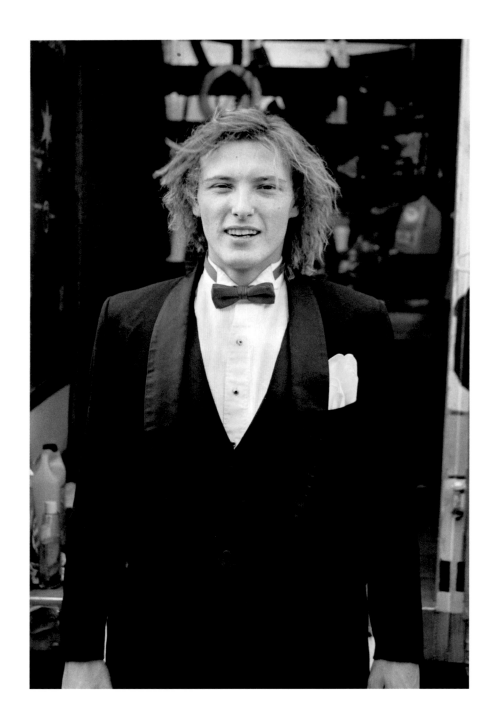

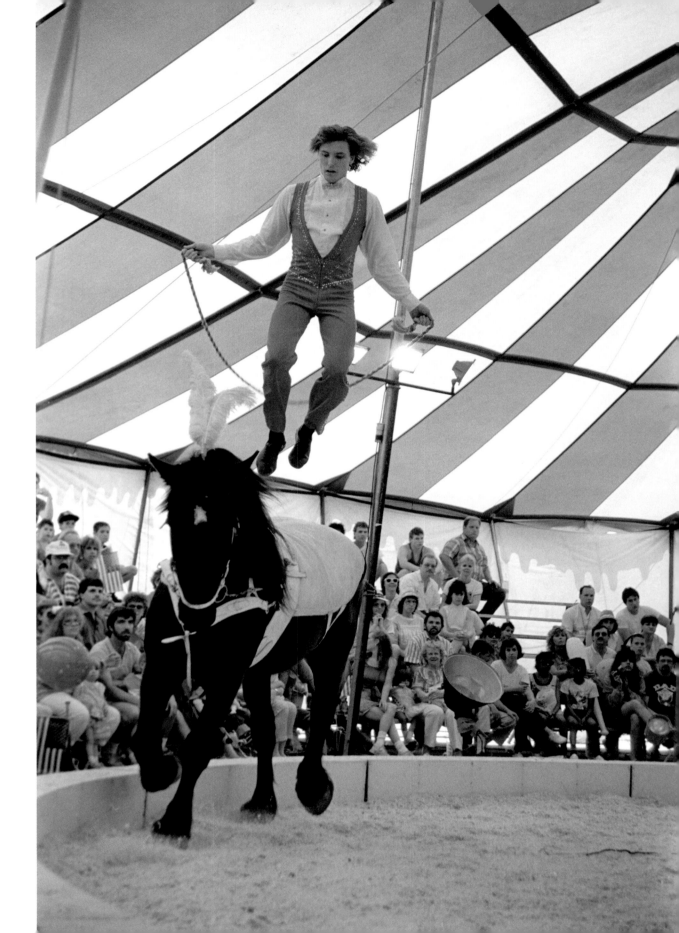

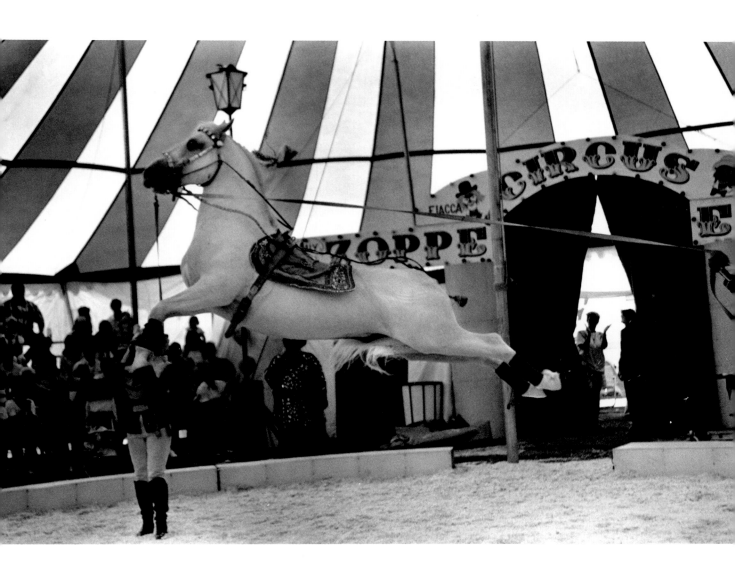

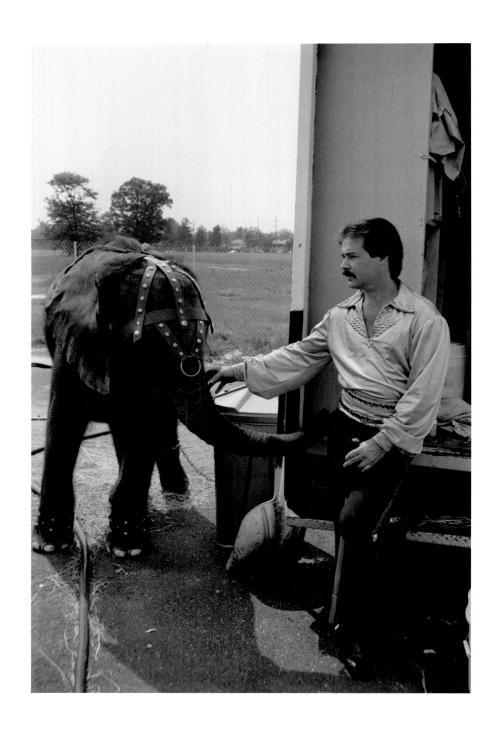

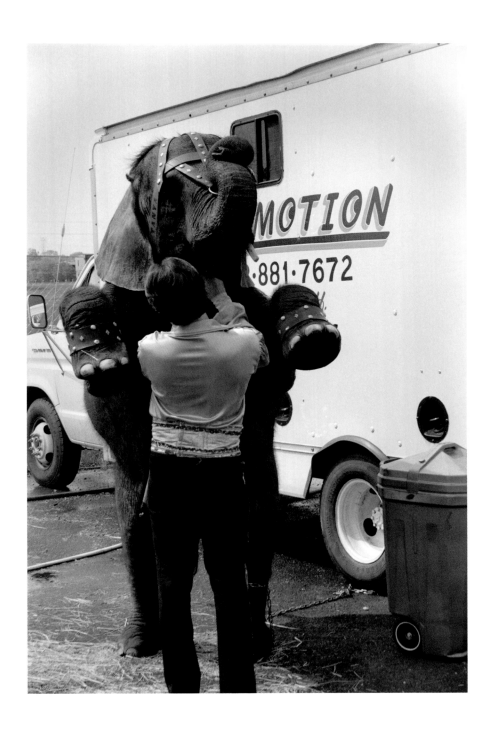

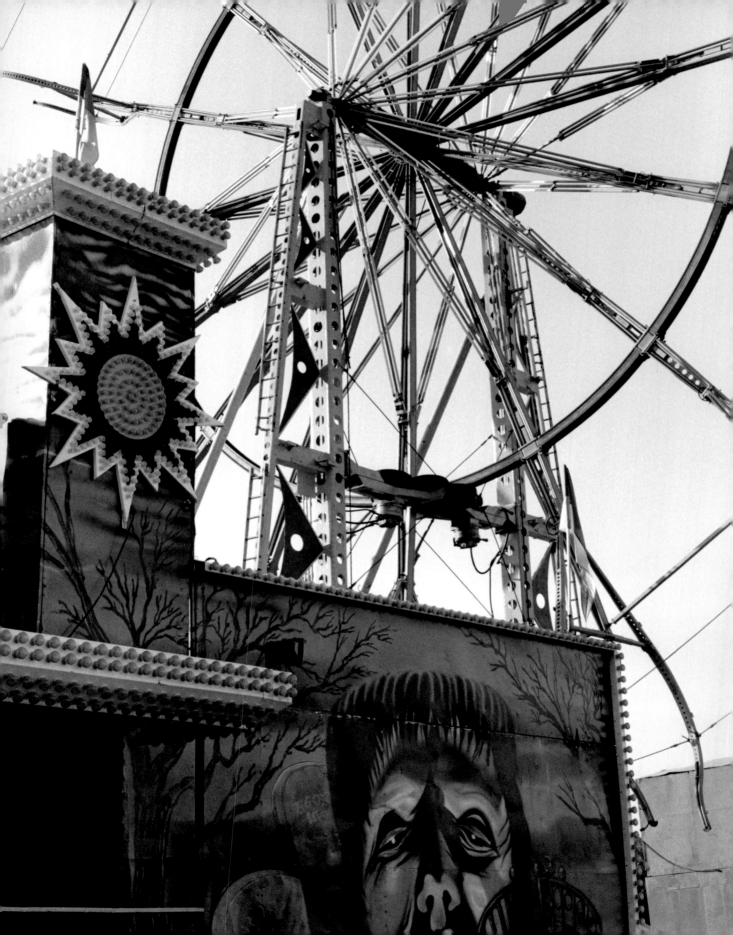

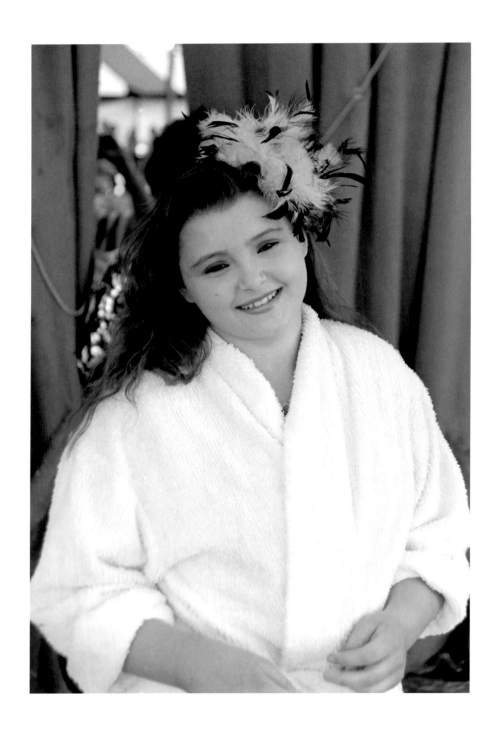

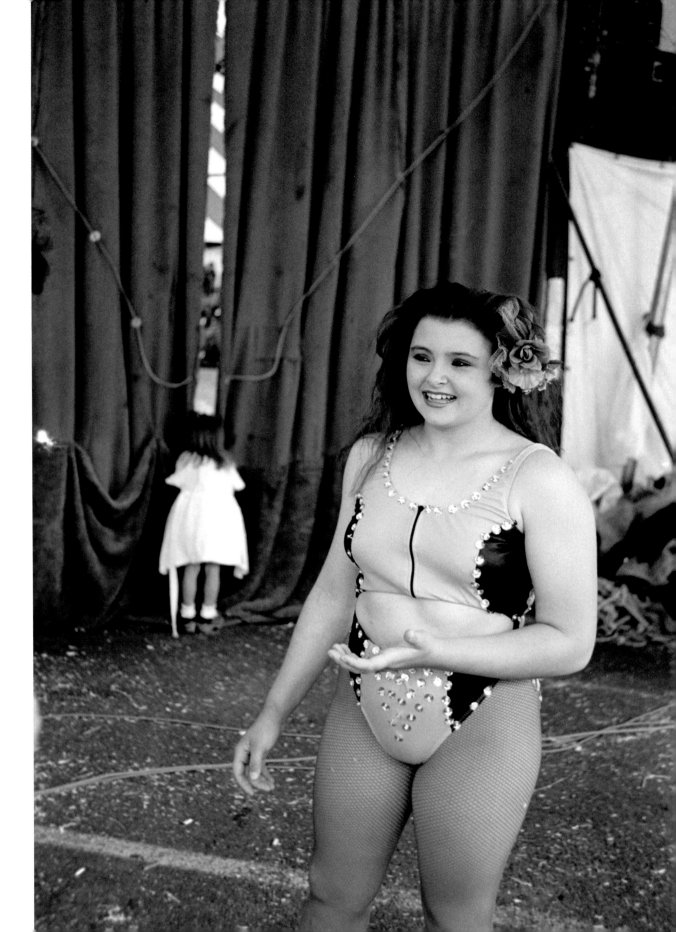

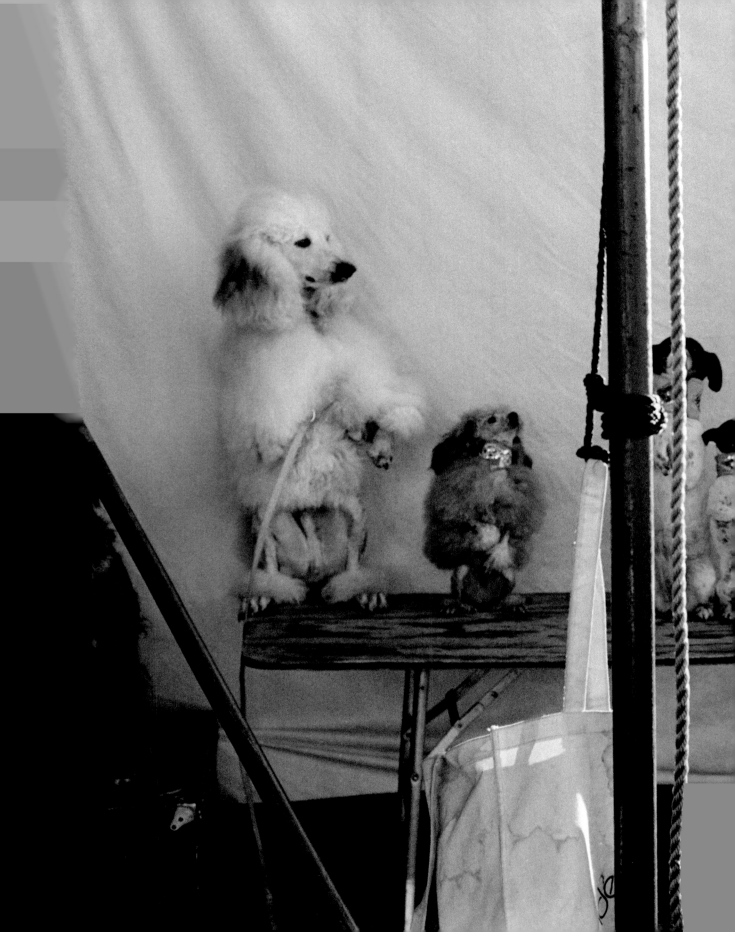

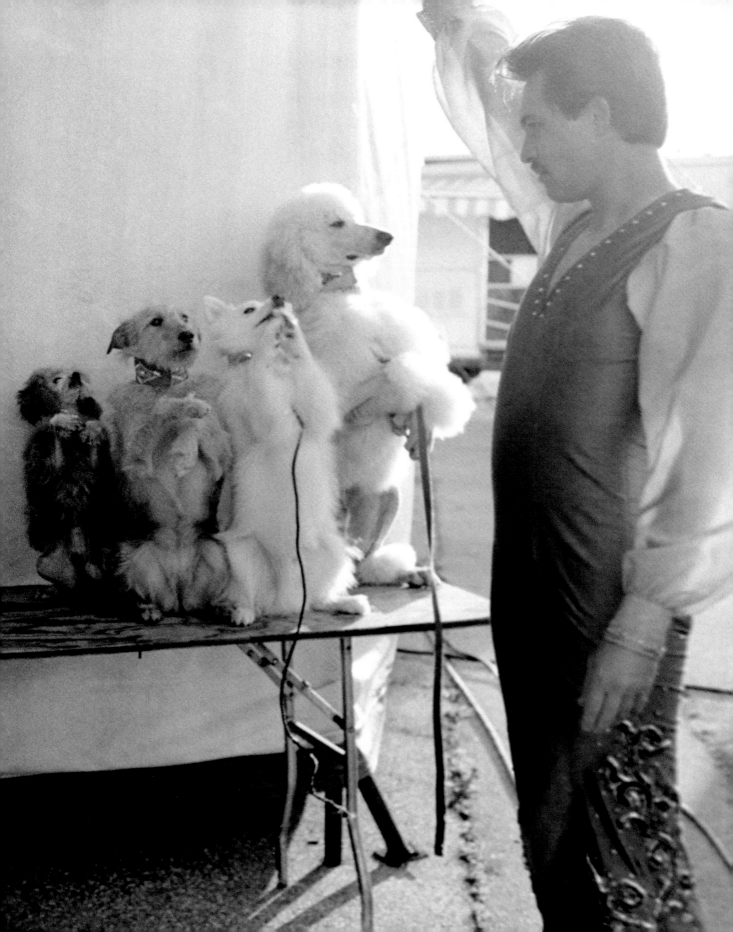

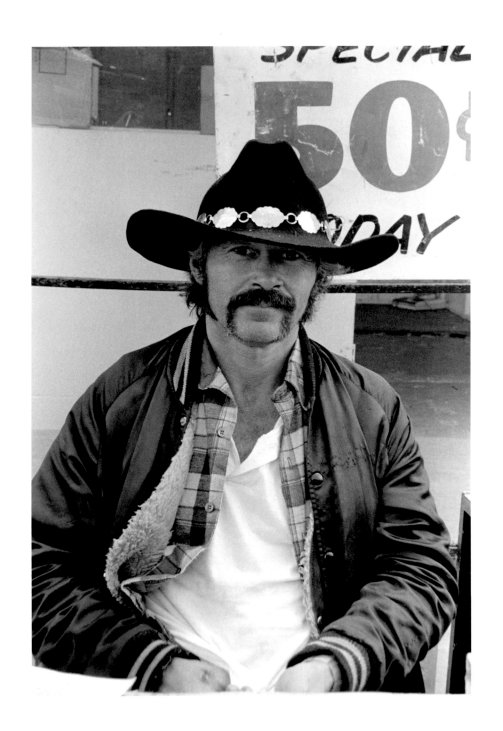

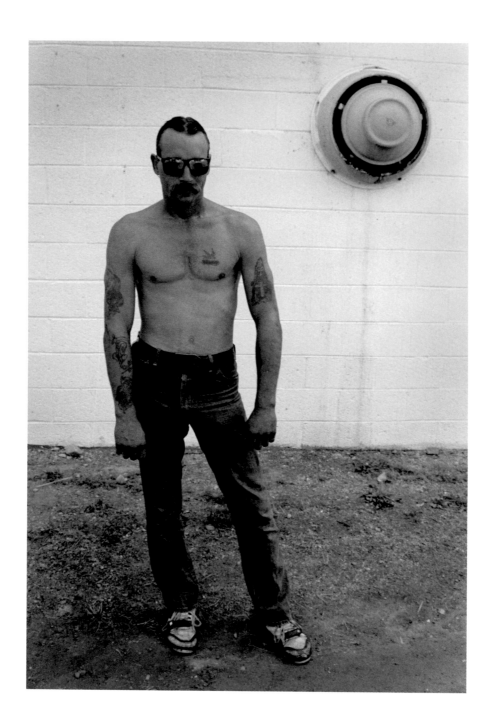

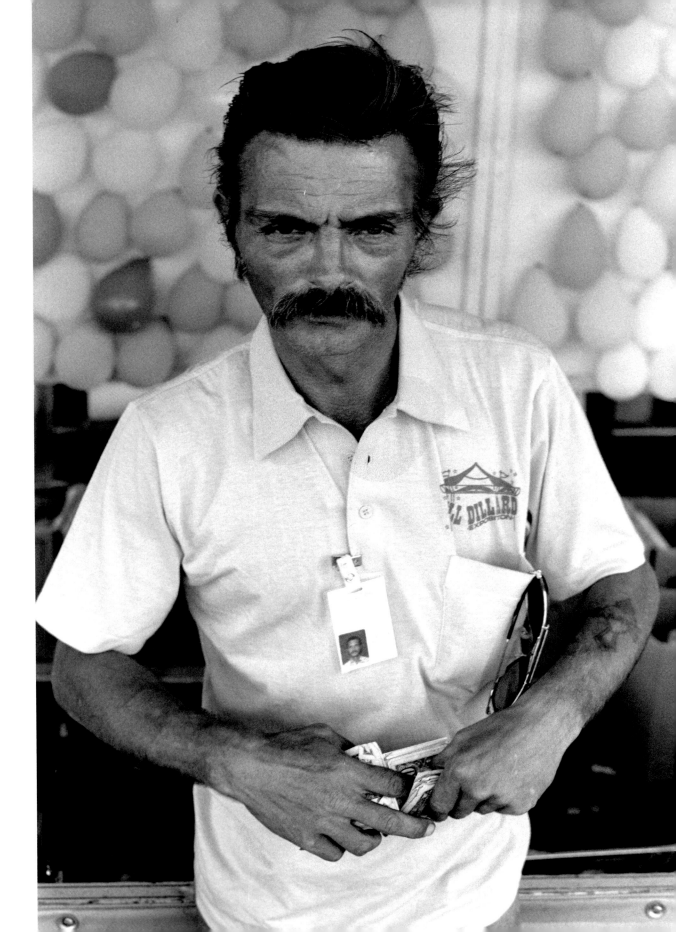

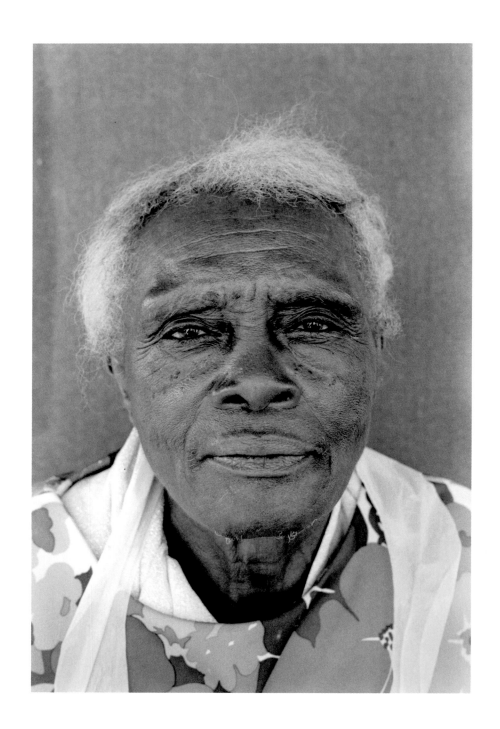

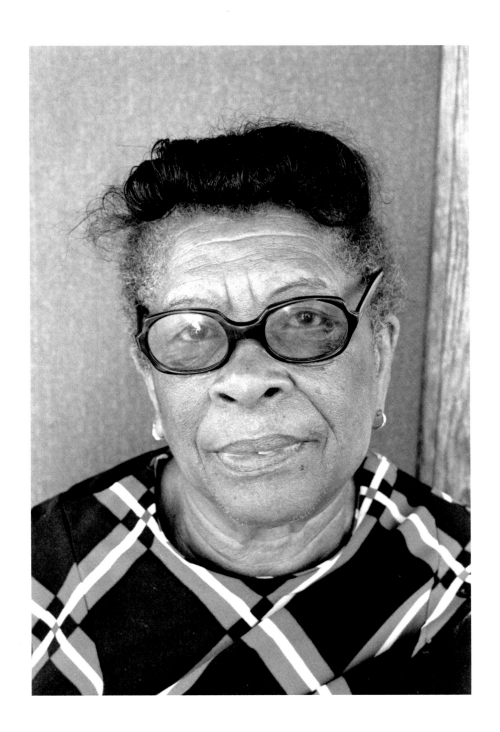

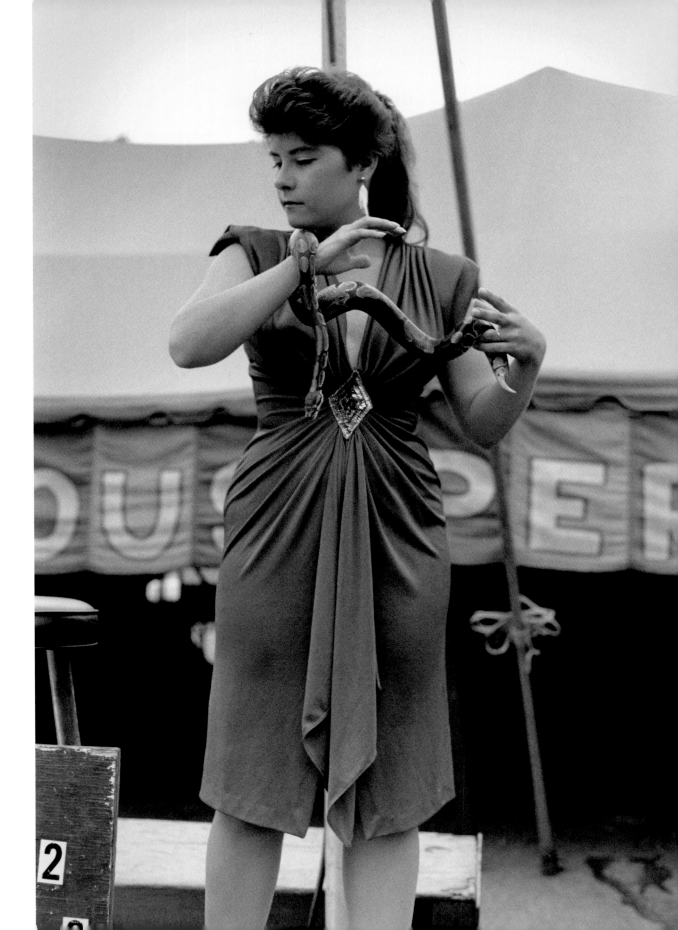

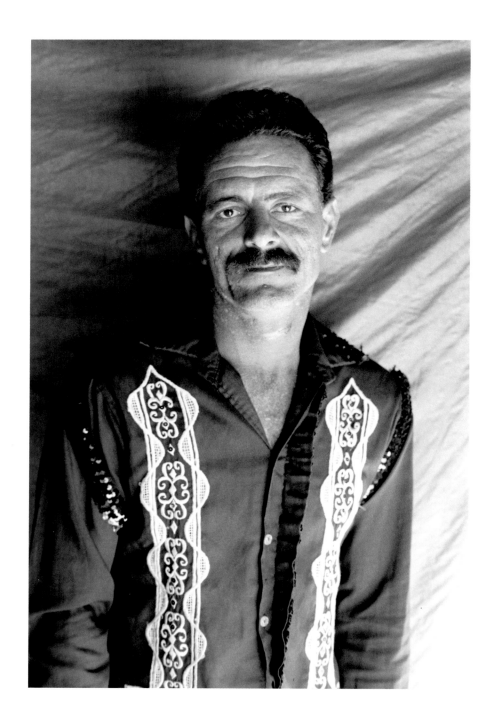

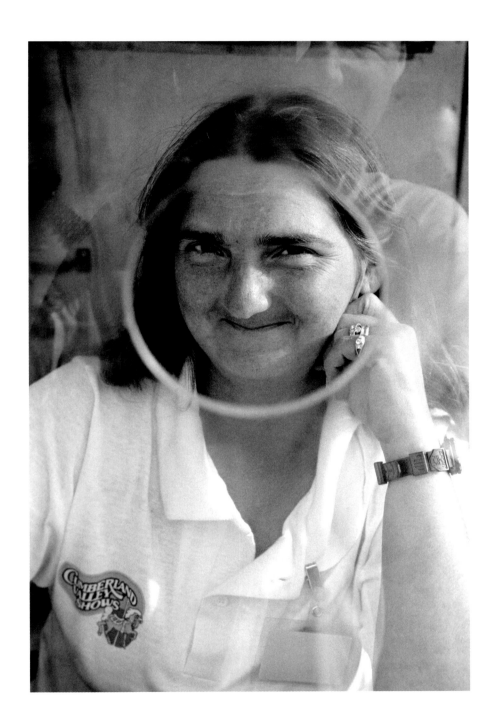

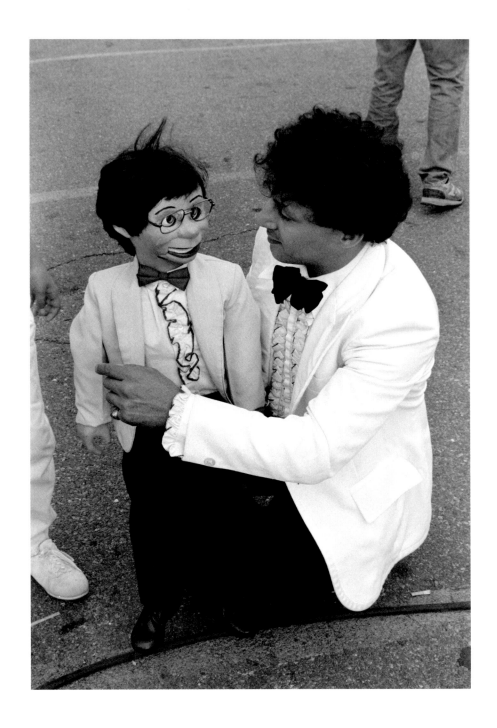

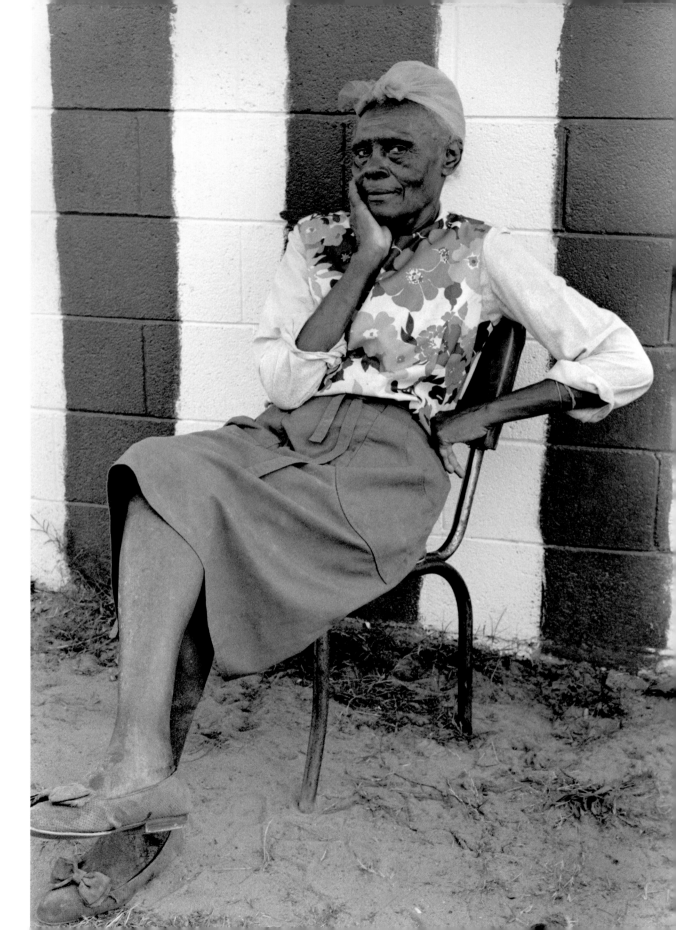

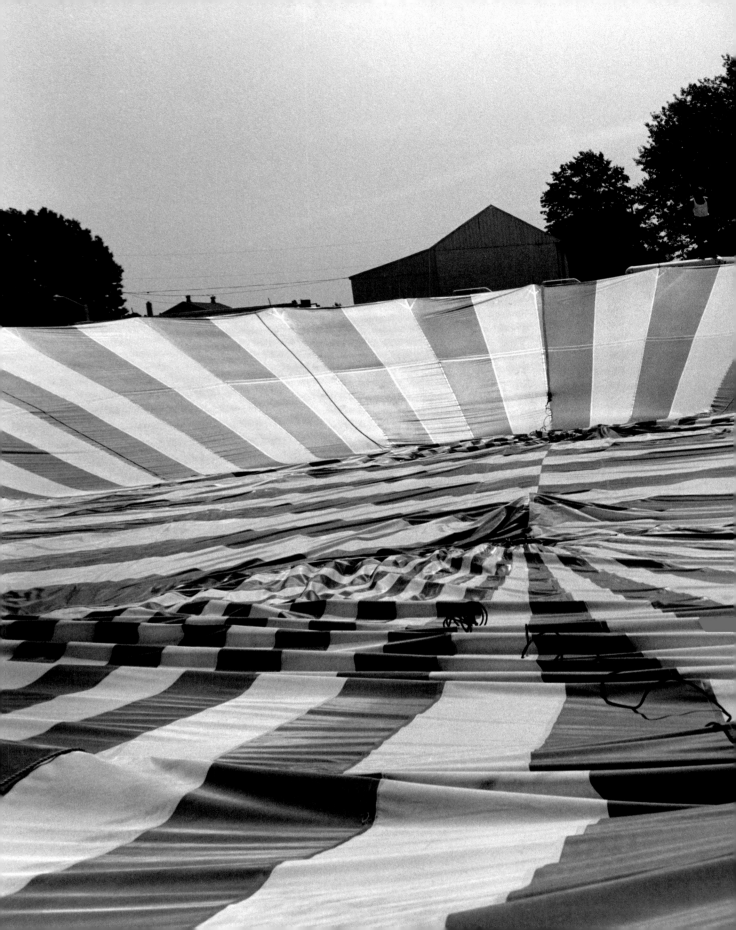

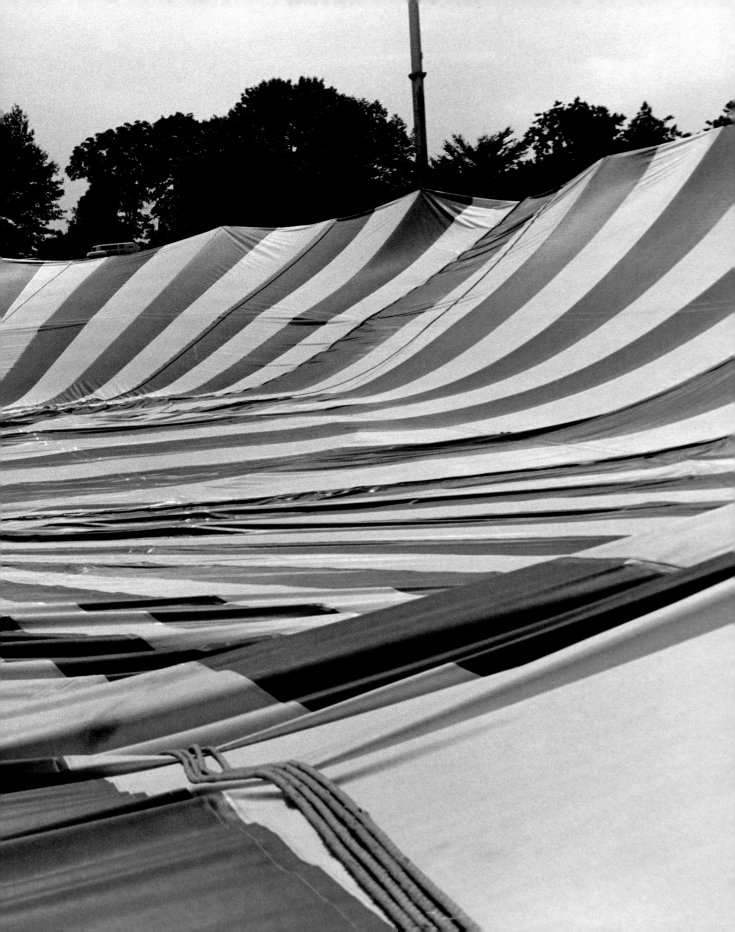

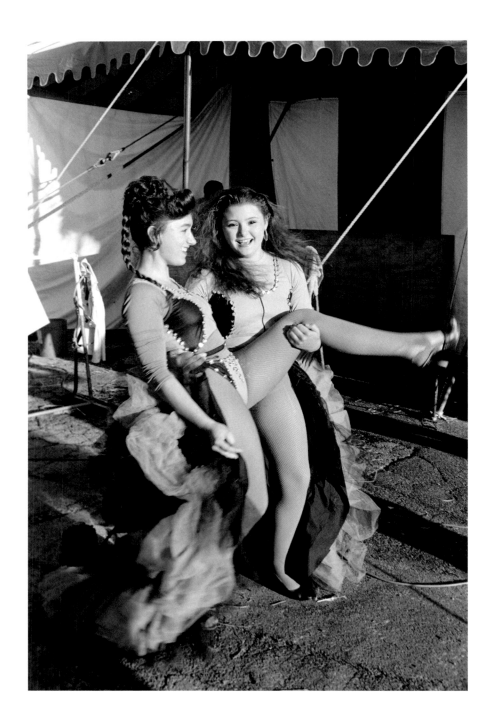

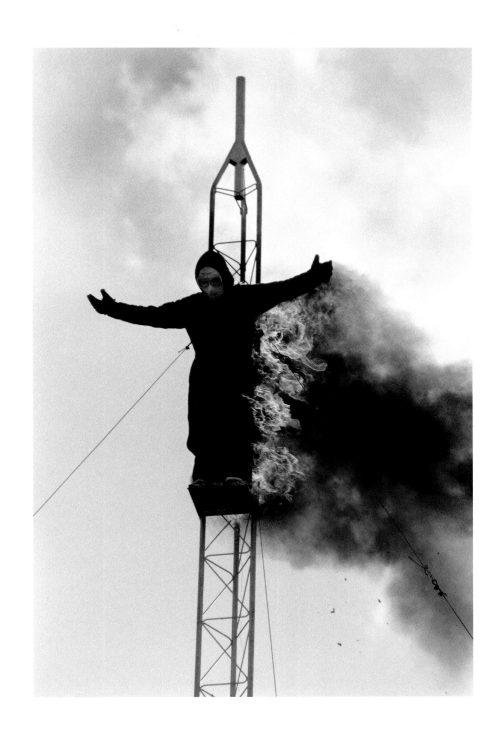

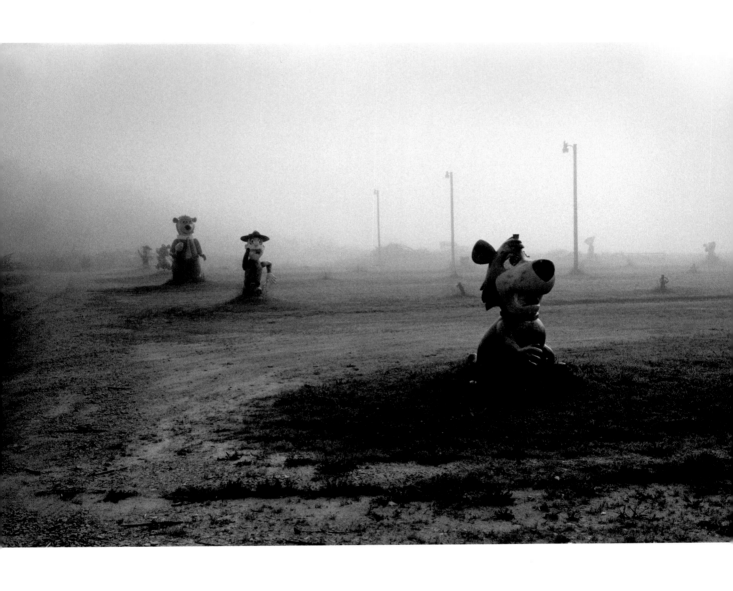

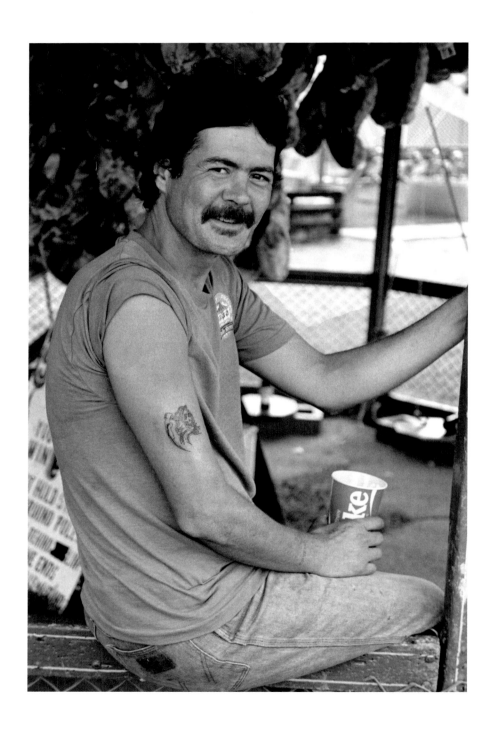

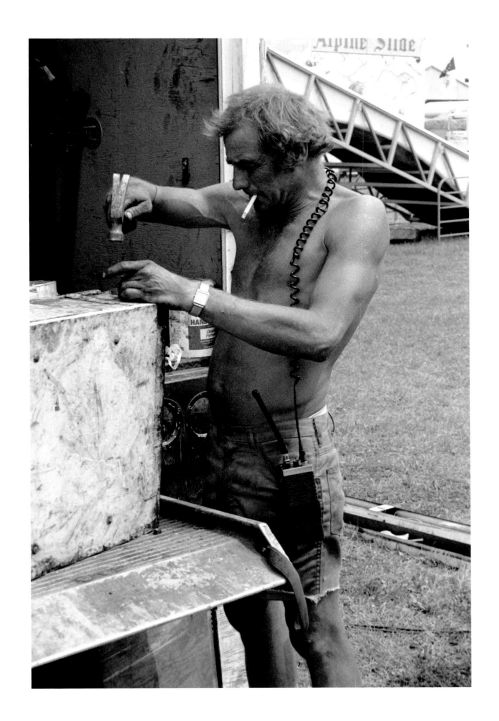

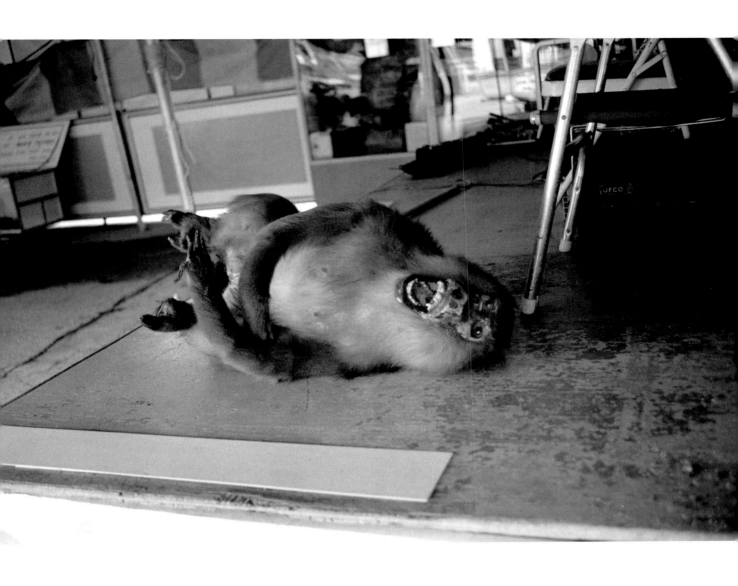

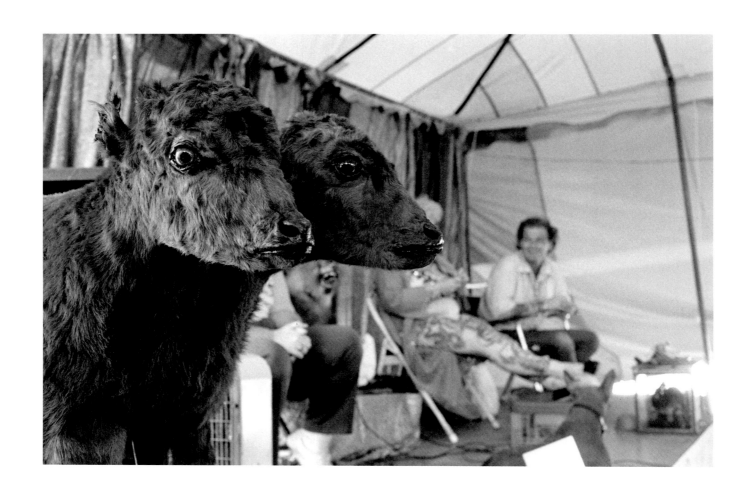

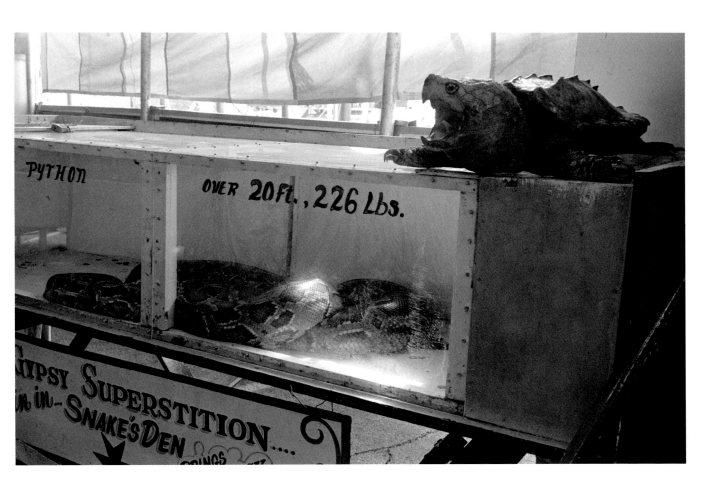

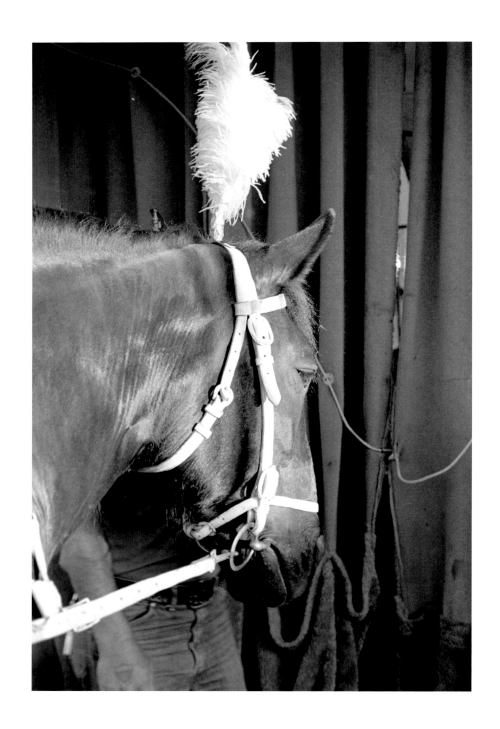

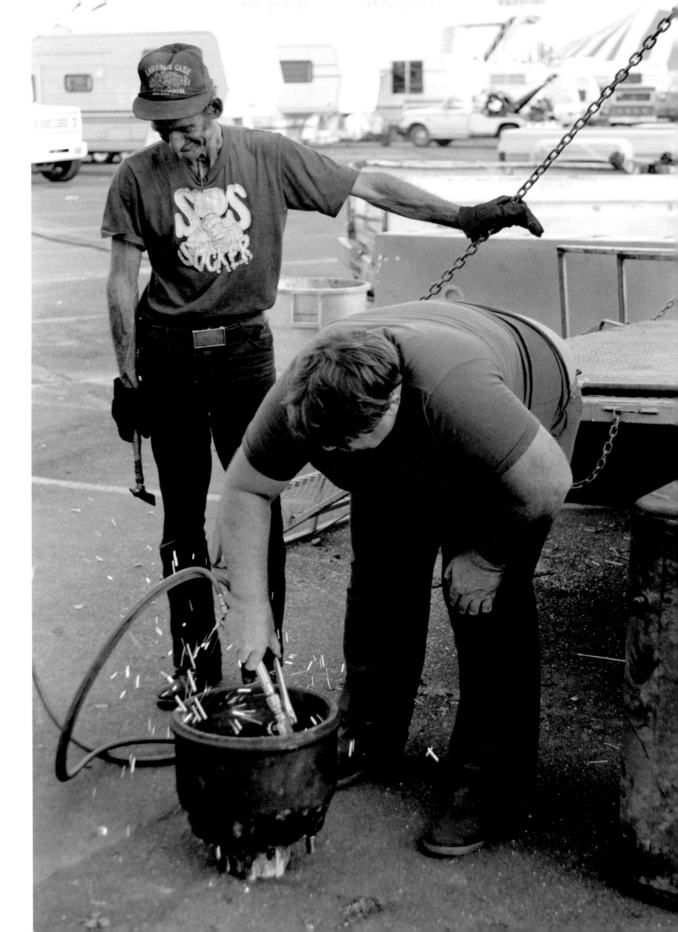

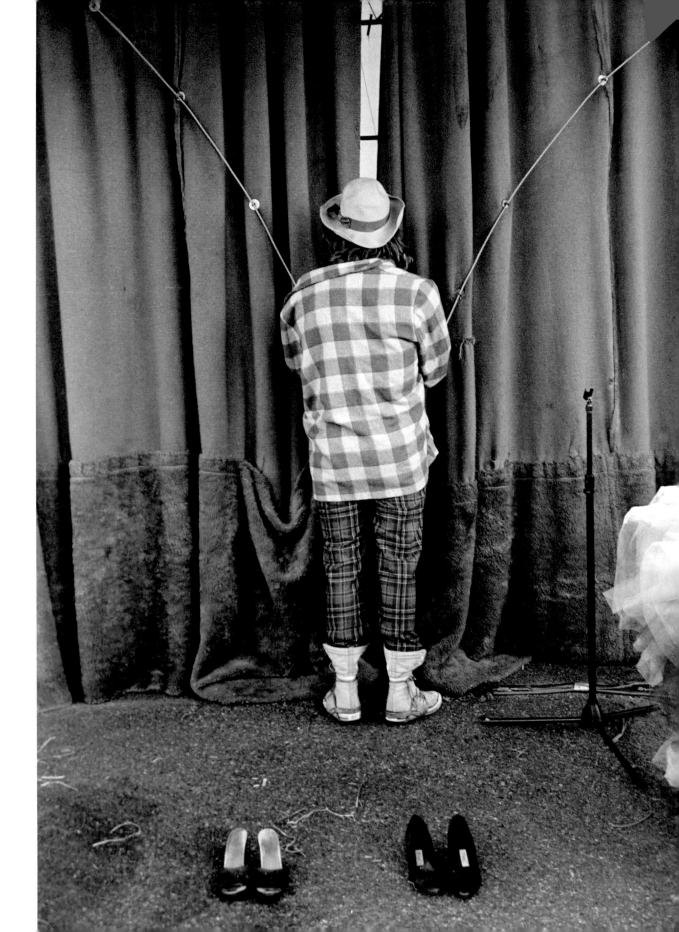

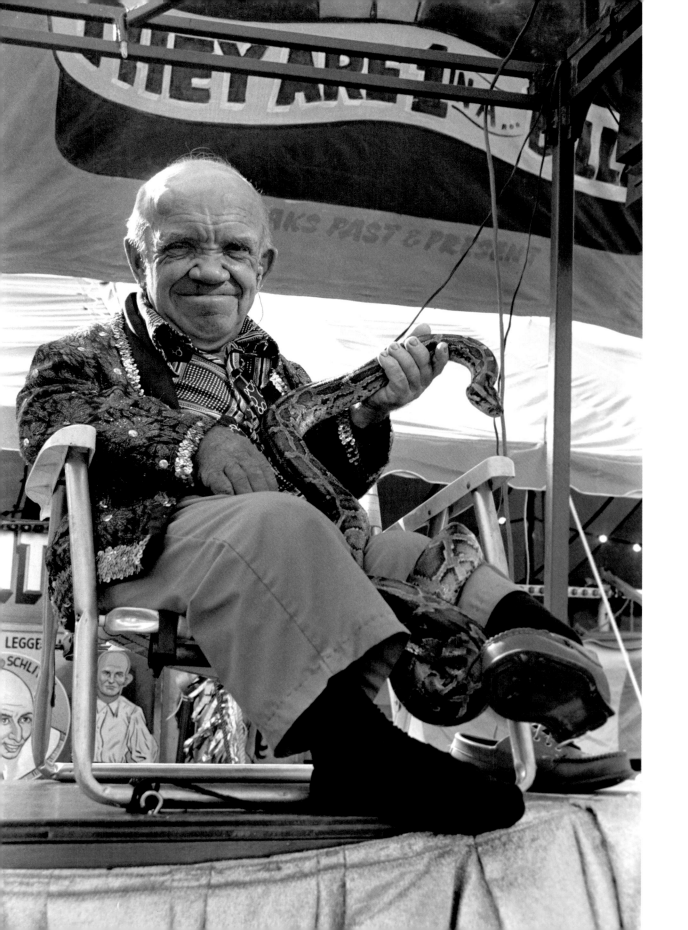

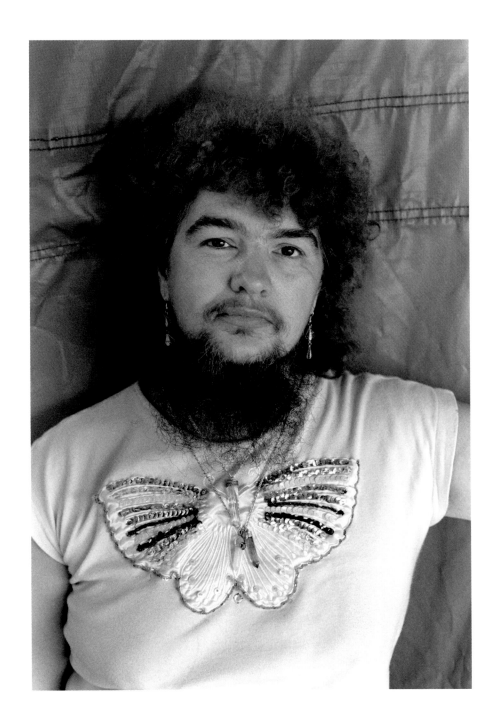

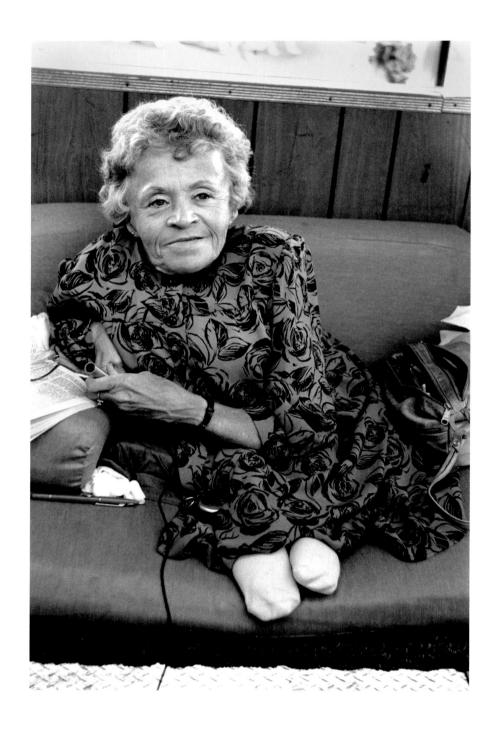

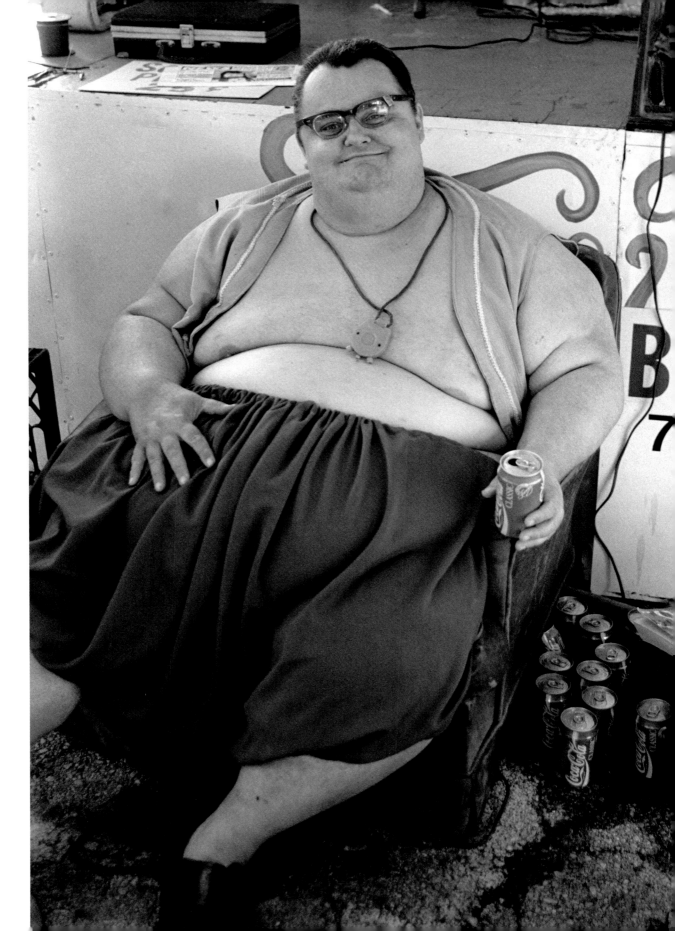

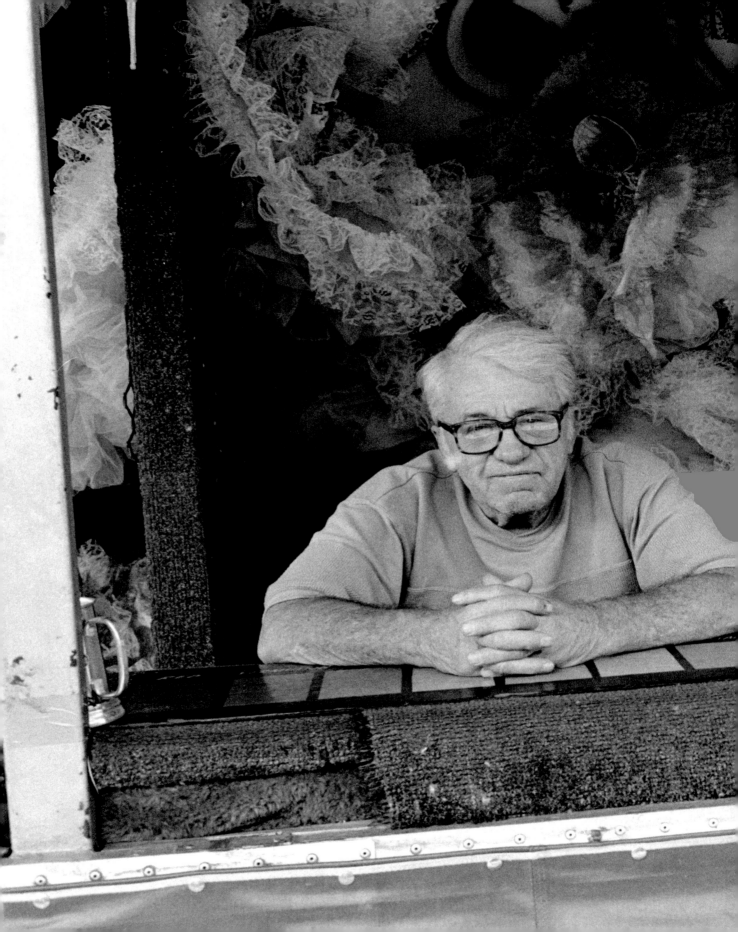

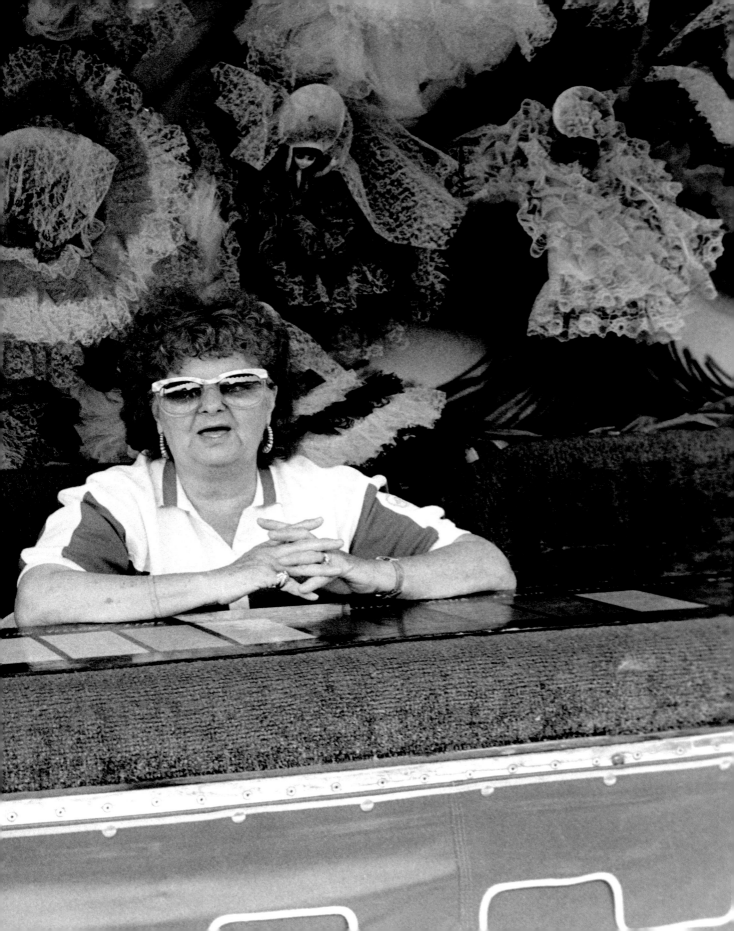

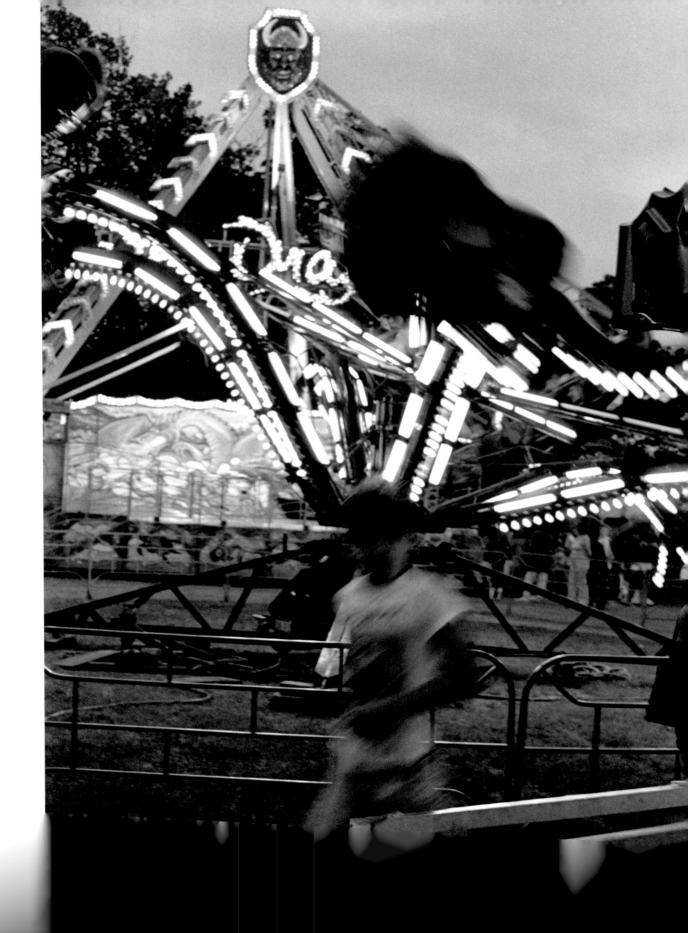

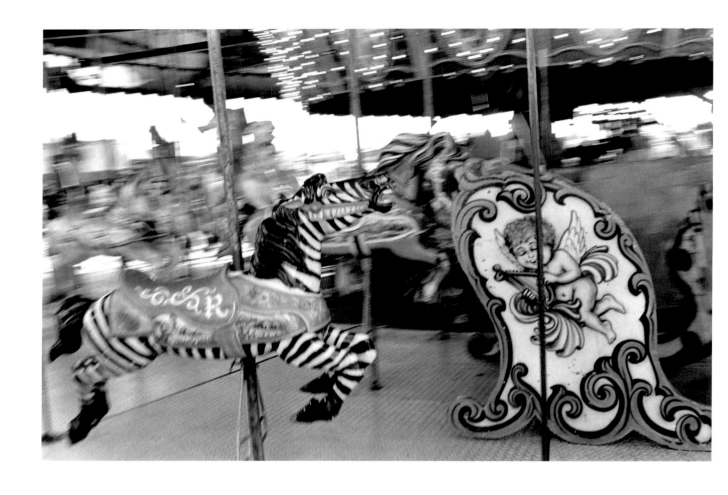

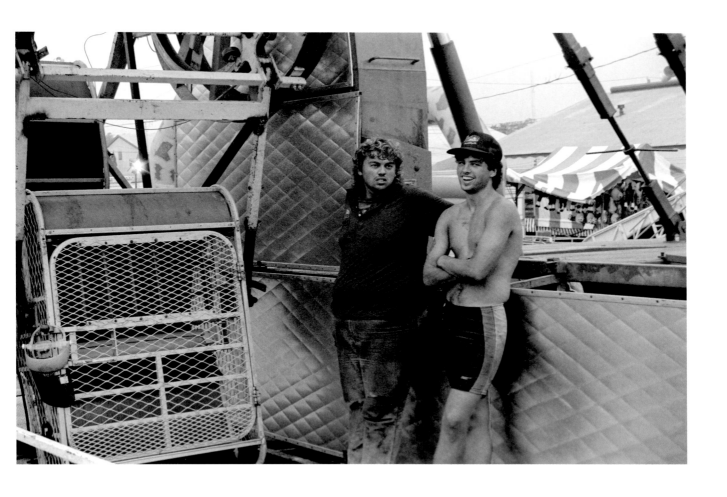

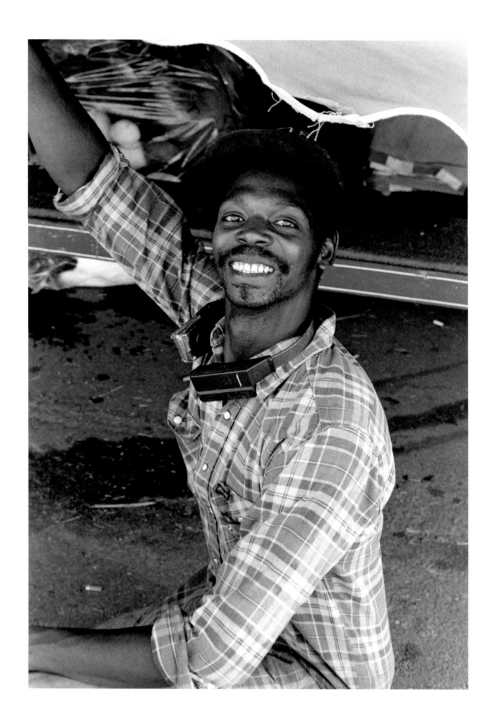

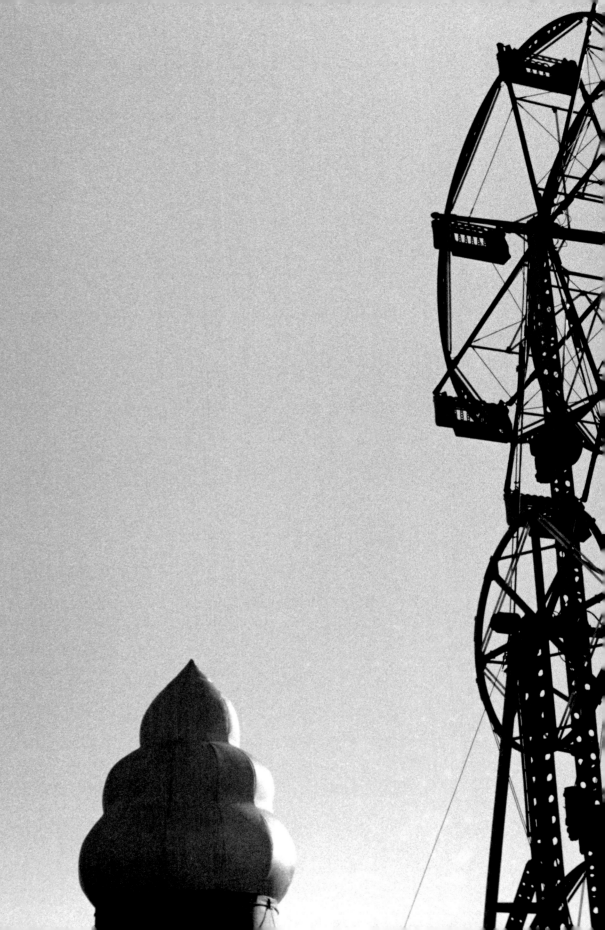

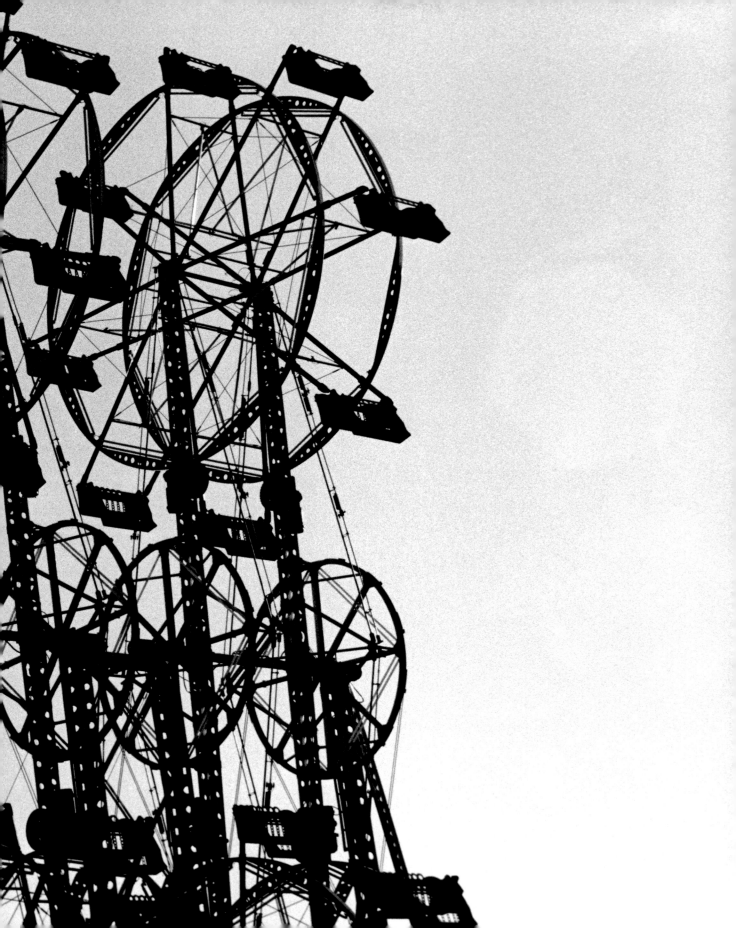

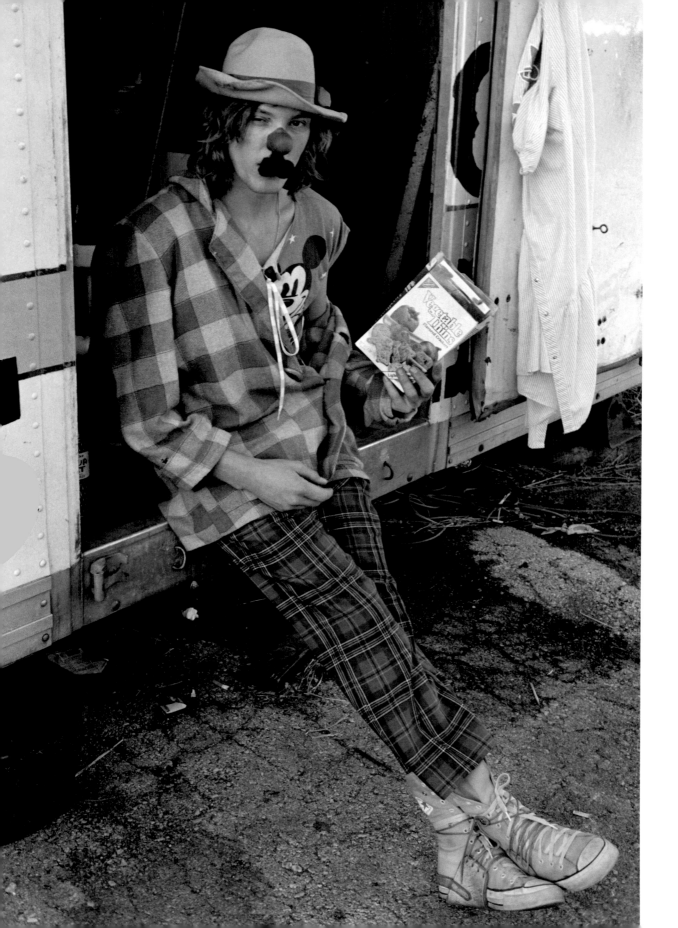

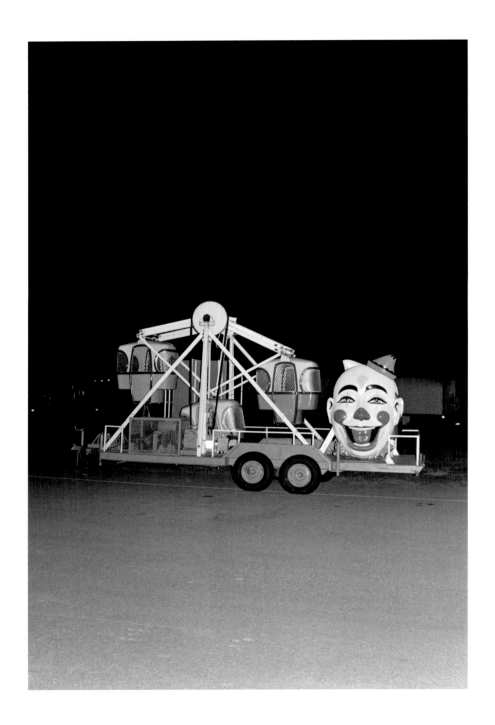

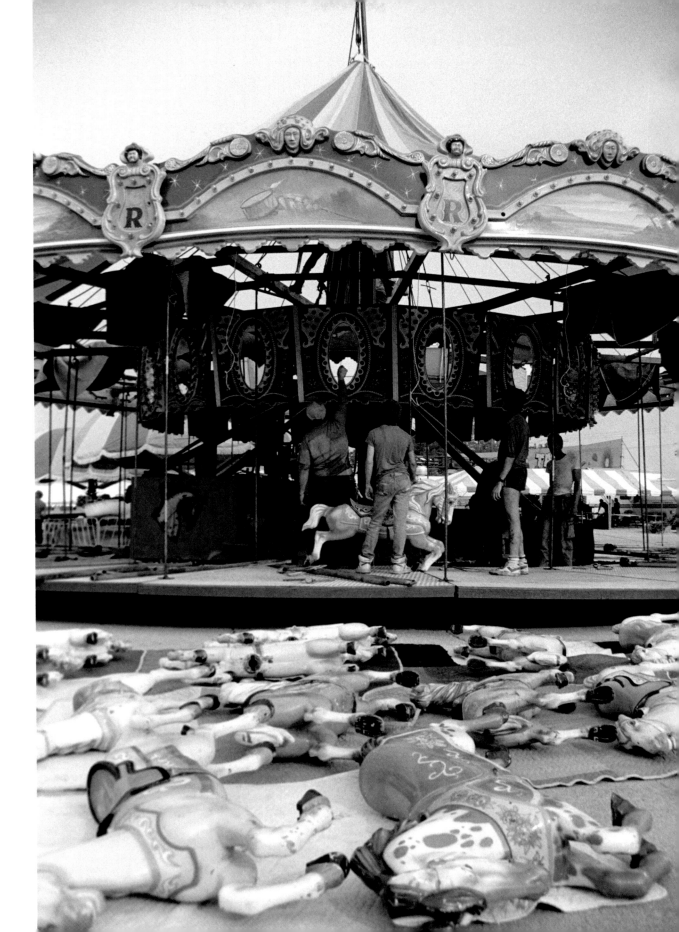

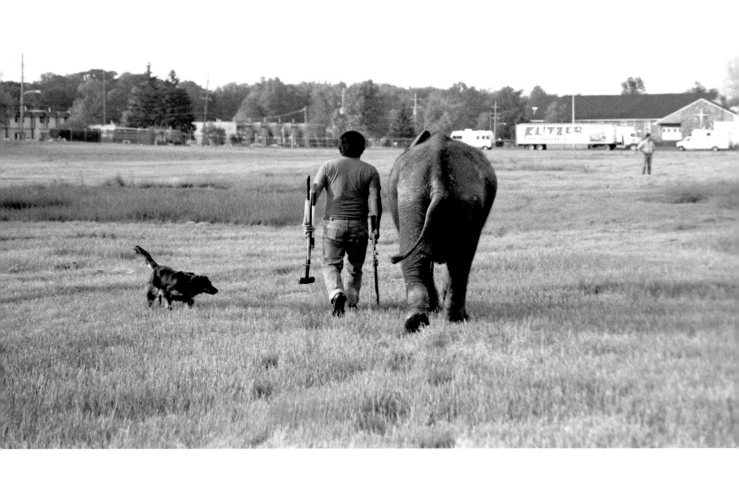

Plates

A Conversation with Dominique Jando and Tessa Fontaine

Tessa:

I'm so excited to get to talk to you a little bit. I'm not sure how much Clayton told you about who I am or how I fit into this puzzle at all, but I'll start by telling you really quick a bit about me and then ask you some questions. So, I have a book that came out in 2018 called *The Electric Woman*.

Dominique:

I've heard of it, yes.

Tessa:

Oh, cool. So I spent a season performing with the World of Wonders, which was Ward Hall and Chris Christ's show. I had an amazing, wild, crazy, wonderful, hard, fill-in-the-blank experience as a performer with them. I think it's a little bit different in the circuses, but in the sideshow we were still performing a traditional grind show. And we were performing from maybe 10 a.m. to midnight, back to back, act to act, so we had to learn every single act in the show. I have a whole host of skills that don't translate super well right now to teaching in college, like fire eating and snake charming and sword swallowing and knife throwing and all of that. Just to start off, I wonder if I could hear just a little bit about how you found yourself in the circus world.

Dominique:

Oh my god, it's a long story. I'm French, and I was raised in Paris. And I'm old. So when I was young and beautiful in my youth in Paris…you know, it's very different, circus in Europe and circus in America, two different animals. And in Paris at the time, we had two circus buildings. One was and still is the Cirque d'Hiver, which is the oldest circus

in the world, built in 1852. And the other was Cirque Medrano, which was, unfortunately, torn down in 1974, but was also a nineteenth-century circus, and those two circuses presented a new show every month. So, in France, and in Paris especially, you didn't wait for the circus to come to town, you just went to the circus. It was here. And my father, for some reason, knew the circus world quite well and he knew a few circus people, and he liked it. He was not a fan, but in Paris, you went to the circus the same way you went to the theater. And my father was also a movie producer, so he was in show business and he was invited to all the openings of one circus or another. And when he saw something interesting, he took me. That started at a very tender age, but unlike most parents who just sit with their kids and say, "Ooh, look at the little pony, ooh, look at the clowns" and things like that, my father would say, "You see this trapezist? What she does is a bit better than what you saw last month." And so as far as I can remember, I've always been interested in the craft in the circus world and very soon I decided that it was what I would do. And it's what I did. I mean my first real job, if I can call that a real job, was as a film editor, which was easy to do because my father arranged for me to learn and do it. But after that, I went into the theater world and through that I managed to reconnect with the circus world. I'm 75 and have been involved in circus since I was 18. So it has been quite a while. And I came to America in 1983. I was recruited by the Big Apple Circus because I had known Paul Binder in Paris, and I'm also the founder of what is referred to as the Paris festival, which is the Festival Mondial du Cirque de Demain. I met a lot of people working

there. I'd been doing this annual festival, which still exists of course, and is still an enormous spectacle. And it's how I met Paul, because he brought a troupe of young acrobats from the Big Apple Circus. Probably one year later, I came to America, and I stayed. I worked for the Big Apple Circus for about twenty years, and after that, I moved to San Francisco to head the School of Circus Center. And I've written a bunch of books, and so forth.

Tessa:
Quite an amazing career.

Dominique:
I've been a clown, just to reassure you that I'm a very serious person. [*Laughs.*]

Tessa:
What does it feel like to be a clown? What does it feel like to be in the costume and the makeup? What's your clown personality?

Dominique:
Being a clown in Europe is hugely different than being a clown in America, because in Europe the clowns are the stars of the show. You speak, you play music. You can be fifteen minutes in the ring, in the single ring. People look at you, listen to you, and, if possible, laugh. I was a clown for about seven years.

Tessa:
And did you have the same clown personality for that whole time?

Dominique:
Of course. I teach clowning here in San Francisco, but if you are a clown, you don't think like actors, you are the characters. It's not a question of red nose and big shoes. The European tradition is much more theatrical, and you play yourself, as a character, the real you. The you that is not afraid of being stupid.

Tessa:
Interesting. I like that idea. We had a clown in the World of Wonders. His name was Rash the Clown, like a rash you have on your body.

Dominique:
You know, I'll tell you something right now, when somebody's called "something the clown" it's not good. You are not "somebody the clown." When you are "somebody the clown" it means you are an artificial character.

Tessa:
Well, he liked to walk around with a dog collar and a leash that he would try to put on other people. I was thinking of him because it was his personality all of the time. He also didn't ever change out of costume and hated to take the makeup off.

Dominique:
That's, uh, that's a problem. [*Laughs.*]

Tessa:
It was fascinating to watch, I'll tell you that much.

Dominique:
I wore very little makeup, but when the show was over I took the makeup off and it was a different world. As a clown I am a performer. I was not a psychopath, or anything.

Tessa:
Right. You weren't the scary, murder-y clown that people are afraid of.

Dominique:
It's like in the theater, you play your character, you play your part, and then you go home and you take the money. That's it.

Tessa:
So did you perform as a clown in the United States and in France, or only in France?

Dominique:
Never. I just taught European tradition here, either in New York where I lived for twenty years, or in San Francisco now.

Tessa:
Do you miss performing?

Dominique:
No, not especially. Actually I stopped performing because I had terrible stage fright before going on. When I was onstage and going, it was absolutely no problem. Now, I've been onstage for different occasions, either hosting a show or doing a conference, and that has completely left me, the stage fright. But at the time it was really painful, so I decided to jump on the other side of the fence. I prefer to take care of the show somehow, to be pulling the strings, rather than being the guy in the show.

Tessa:
Just the man behind the show, making it all happen.

Dominique:
Yeah, it's more fun actually. There are more things to do.

Tessa:
I know you've written a number of books and I'm wondering how you approach writing about the very unique, vibrant world of the circus. You've written a lot of historical accounts too, but how do you go about trying to capture that energy of the circus in words?

Dominique:
I don't try. I just write. You know, I'm a historian mostly. I have written, and still do, a lot of criticisms and reviews of circus shows, so that's also a different approach. The only book in which I tried to bring the atmosphere was the enormous Taschen book, *The Circus*. It was historical in

a way, but it was mostly a picture book, and so the text had to go with the illustrations, to be as vibrant as the illustrations. You know, I am an artist, so I have a very visual memory and it's not very difficult for me to describe the images I have in my head. You suffer when you write a book, because you are in front of a white page, but how to do it, I have never suffered about.

Tessa:
You are a lucky man then. One of the things that I found so surprising and delightful before I started writing about the sideshows was wondering if I was doing something bad if I wrote about how some of the acts are done. Is it like revealing the magician's secrets to write about how fire is eaten?

Dominique:
Magicians don't reveal their secrets. I know some pretty well, so I know a lot of secrets. But that's for us professionals.

Tessa:
Yes, I agree with you. But here's what I started thinking about more, for example, with something like eating fire. The reality of how you do it is amazing, but I think people always assume there's some trick. And so to be able to say, no, you're actually putting real fire in your mouth and you're actually touching it to your tongue…I think that pulling back the curtain on some of the sideshow arts felt like this kind of confirmation of how wonderful they are and how amazing. I liked that a lot.

Dominique:
Yeah, I mean if you go beyond spitting fire, you just become Guy Laliberté and create Cirque du Soleil. Spitting fire is just the beginning.

Tessa:
Clayton was wondering about this. Have you encountered sideshows along the way in your circus life?

Dominique:

You know, sideshow and circus are connected only in America. It's absolutely not in the worldwide tradition of the circus. It's a purely American phenomenon which came to be because Phineas Barnum started with that, in a way, with the Barnum's Museum in New York. And when he started in the circus business with Hutchinson and Coup, he just brought what he was famous for. He already had circus acts in the museum, but onstage. And he brought the menagerie, and it was a normal addition to a circus for him. And he brought his sideshow, for which he was famous. So he created this combination which was, little by little, copied or taken over by his competition. But it's really purely American. There had been some instances of what you would call a sideshow in Germany between wars, in the giant German circuses, but it was not really the same thing in the rest of the world. It was presented as exoticism. So you didn't really have freaks, you had "exotic" people, like Native American tribes or Chinese families, doing something. And not as a pure exhibition. But the sideshow as such existed in Europe only on the fairgrounds. It was not connected with the circus.

Tessa:

So you didn't encounter any in your time in Paris?

Dominique:

I saw sideshows on the fairgrounds. But it was not connected at all with a circus.

Tessa:

It was interesting for me being out on the road with the sideshow because the way the World of Wonders works now is we just played in different fairs, like state fairs and county fairs, and traveled all around. Although, we were independent contractors, so we didn't stay with a particular carnival company. We were with different ones all the time. I think there was only one time we were at a fair where there was also a circus performing. We were sort of our own independent thing.

Dominique:

You were just neighbors. Because the sideshow disconnected from the circus in America a few years after Ringling folded its tents, which was in 1956. By 1970, there was not much left of the sideshow in the circus world.

Tessa:

I talk to a lot of sideshow historians and people involved in the archives and there are so many different interesting opinions about why that has happened, and also what has led to the changing way that the circus is perceived in America. I know for the sideshow in particular, one of the things that changed it a lot was disability rights legislation in the 1960s, which changed who could be onstage and how they could be presented. A shifting public awareness about what was appropriate or not to look at was also influential. I'm wondering, what are some of the big things you feel have changed in the circus?

Dominique:

Of course things have changed, for the circus itself has changed. You know, you look at the circus that Phillip Astley presented in the 1780s and then John Bill Ricketts here in America, and so forth. It was an equestrian show. Hence the ring. And it was an equestrian show presented along with some traditional things like rope dancers, jugglers, tumblers, contortionists, but the most important thing in the show were the horses. So, if you look at it today, it has of course changed a lot. First, because at the turn of the twentieth century, the horses were the most important thing in human life for everything from transportation to war to agriculture. Everybody knew what the horse was, everybody was familiar with horses, but that changed after the First World War. It was like a different world. And

the shift went on to acrobatics at the turn of century, the time of the creation of the Olympic Games. Before the Olympics and before gymnastics competitions, if you wanted to see acrobats or gymnasts, you had to go to the circus, it didn't exist elsewhere, so the show became much more an equestrian show with a lot of acrobats and aerialists. So that was another evolution. And then with the colonial empires that were created in Europe, the British Empire, the French Empire, the tiny German Empire and so forth, you started seeing wild animals, which before were confined to the menagerie and suddenly entered the circus ring. In Europe the circus was never in the hands of businessmen, but always in the hands of circus men and still is.

If you're a small family circus, you have your daughter do a little bit of contortion and your son do a little bit of juggling. If they are talented, they will get out of the family, but if you have a bunch of animals, you can just present them and you don't have to hire a huge company. Although animals are expensive to maintain, it's not the same problem you have with a bunch of artists. So the circus evolved to include a lot of animals, although a good circus still had very good acrobats. And if you take the best circus in the world today, which is Circus Knie in Switzerland, it's a family of equestrians. Originally it was a family of rope dancers, but they turned equestrian because the aristocracy of the circus world are the equestrians. And they are now the best equestrians in the world, along with the Richter family in Hungary and the Gruss family in France. And the acts these circuses present are incredible. Acts from all over the world, of great quality, and people who can win Gold Clown in the Monte Carlo festival. Things like that. So, in a really good traditional circus, the horses are still there, and you can survive without a menagerie. And it's totally stupid to think that circus people beat their animals, because it's all contrary. Usually it's people who

don't know anything about animals who think that and who spread the information that circus people are brutal. It's the world in which we are living. So now you see fewer animals, but in a way, for me, as much as I like a good animal act, a circus with horses and acrobats is enough to satisfy my taste.

Tessa:
I'm thinking about what you were saying with all of these circuses being family acts. I know that's how it's been historically and how a lot of the shows have developed, and I'm thinking about being in the sideshow. I wasn't related to anyone that was out there and yet we all lived together in the back of a semitruck and a trailer, and we were on the road together nonstop for all these months, and so you get this sort of family relationship in a way. I mean family in the best and worst way.

Dominique:
Families are one thing. There are circus families, and they are distinct from the rest of the world because they are circus. The thing with the sideshow, it's exactly the same thing. You travel to communities to whom you are a foreigner. And not only a foreigner, but a weird foreigner. Sideshow is even weirder. But even in a straight circus show you are somebody who can balance on his head on a trapeze, which is slightly weird. In Europe it's different because the circus has a lot more respect than it does here. But people are always afraid of what they don't fully understand. And so if you are traveling, arriving in a community and showing something that this community is not used to, you are a sort of a pariah. I mean, it's fine, they're fun, but they don't want to speak to you. And it's why there is circus community and maybe sideshow community or carnival community, which are going to be very tight-knit.

I've been in the circus for quite a while. The circus is a very international community and I'm very well

known in the circus world, first because I worked in the circus and in three very good ones. And then because I'm one of the founders of the Paris festival. And also because I wrote a bunch of books on the circus. So if I go to Russia, people know who I am, and if they don't know, I say who I am and what I did and they understand I'm family. Same thing in China, same thing in South America. Wherever I go. So, in a way, my country is the circus.

Tessa:
I love that idea.

Dominique:
No borders, nothing. We are just who we are, together. And it's the same thing in all. The carnies are the carnies. It's just because you have to protect yourself, and so you get together and you feel comfortable. It's insidious in a way because, for instance, if you go to Moscow there are still two permanent circus buildings. There is also a permanent circus building in Paris, the Cirque D'Hiver. But still, although they are totally part of the cultural fabrics of the cities in which they perform, they are still circus people, because the old traditions are still there.

The Bouglione family is a family of gypsies actually, and until they bought the Cirque D'Hiver in Paris in 1935, they had never had a place to live. They first had a traveling menagerie and after that, a traveling circus. It was between the wars, so at the time you could still make lot of money. And then they bought the the Cirque D'Hiver and suddenly, as the old patriarch of the family, Joseph Bouglione, who passed away a long time ago, told me once, "And then we bought this circus and we didn't know what to do with it." To which I answered, "I think you did pretty well." [*Laughs.*]

Tessa:
Sounds like they figured it out. One last thing, since I know you're a historian and have written so much.

Is there just one small piece of circus history that you feel isn't very known that you could share with us?

Dominique:
I'll tell you what I love in the circus and what attracted me to it in the first place, and why I stayed there. And why I'm pretty proud to be part of it. First, it's not a bullshit world. When you do a somersault, you do a somersault. You're not pretending that you are able to do a somersault. And it's the same with the classical ballet. When you are a great dancer, you are a great dancer, you don't have to pretend you are. Everybody knows it. It's the same thing in the circus. Everybody knows who you are and what you can do, and you are respected for what you do, whatever that is. And no one thinks they are more interesting than the other because everybody knows the amount of work that has to be done to reach a certain level. So that's very healthy, in a way. I worked in theater, where you have a lot of actors who think they have a great talent, but nobody has seen it yet. In the circus you have seen it. And there's no discussion. You can hate somebody, but you will respect the talent if there is talent. When I speak of Mstislav Zapashny, he was one of the most hated persons in the Russian circus, as a person, because he was not a very nice man, although I had a very good rapport with him. But people really didn't like him. But when he died, everybody came to acknowledge who he was as an artist. Because you all know that, you all share the same values. The tenets and principles of the circus world are the same for everybody and everybody respects them. So for me, it's very comfortable to be with these people because you don't have to explain things, they know who you are and you know who they are. And that's it. And if you have no talents, they will know that you have no talents and you will not make a lot of friends. Good talents, you will be respected and admired by everybody without exception. It's a world which has its own laws and one of them is, bullshit is not welcome. And I like that.

Katharine Kavanagh is a circus writer and researcher with a background in devised performance. In 2013 she launched the online platform The Circus Diaries, which is now a digital hub for critical response and circus thinking. She has taught at institutions including the National Centre for Circus Arts, Circomedia, and Stockholm University of the Arts (SKH). Katharine is currently pursuing a PhD on circus criticism and audience experience at Cardiff University, and can otherwise be found working in children's hospitals as a Giggle Doctor for Theodora Children's Charity.

Jack Pierson is an artist who works in several different mediums, including sculpture, photography, and video, and is known for word signage installations, drawings, and artist's books. He graduated from the Massachusetts College of Art in Boston in 1984. He lives and works in New York. Pierson has had recent solo exhibitions at the CAC Malaga, the Irish Museum of Modern Art, Dublin, and the Aspen Art Museum. His work is in the collections of the Metropolitan Museum of Art, the Whitney Museum of American Art, the Solomon R. Guggenheim Museum, the Museum of Contemporary Art, Los Angeles, and the San Francisco Museum of Modern Art, among others worldwide.

Tessa Fontaine is the author of *The Electric Woman: A Memoir in Death-Defying Acts*, a *New York Times* Editors' Choice, finalist for the Utah Book Award, and best book of 2018 from *Southern Living*, Amazon Editors', Refinery29, PopMatters, and the *New York Post*. Tessa spent the 2013 season performing with the last American traveling circus sideshow, the World of Wonders. Her writing can be found in the *New York Times*, *Glamour*, the *Believer*, LitHub, and *Creative Nonfiction*. Tessa won the 2016 AWP Intro Award in Nonfiction, founded Salt Lake City's Writers in the Schools program, and has taught in prisons and jails around the country. She currently lives in North Carolina, where she teaches creative writing at Warren Wilson College.

Dominique Jando began his involvement with the performing arts more than five decades ago in his native France, at the legendary Cirque Medrano in Paris. He served as general secretary of the Paris Cultural Center, and participated in the creation of France's first professional circus school and of Le Cirque à l'Ancienne, which eventually became the French National Circus. He was the associate artistic director of the Big Apple Circus for nineteen years, and the creative director of Circus Center in San Francisco, California. He is vice president and artistic director of Lone Star Circus in Dallas, Texas, and serves on the board of Circus Bella in San Francisco. He is also founder and curator of Circopedia.org

A circus and popular entertainment historian, Dominique has published several books and numerous articles on these subjects, both in Europe and the United States. He teaches at San Francisco Circus Center's Clown Conservatory, and is the international circus consultant for Guinness World Records, Ltd. He is also a founding member of the Festival Mondial du Cirque de Demain, an international circus competition, and has served on the juries of international circus festivals in Europe, Russia, Mexico, and Israel. Dominique is the recipient of the 2016 Elevating Circus Award. He is married to award-winning trapeze artist and aerial arts coach Elena Panova. They presently live with their two cats, Minoushka and Polina, in San Francisco, California.

I'd like to thank the Zoppé Family Circus for befriending me so many years ago, the performers of the World of Wonders sideshow who were patient with my many requests to take photographs, and Sharon, who knew the ropes and taught me the lingo.

Thank you to my family: Kim, Scott, Michael, Kristin, Ben, Marlene, Tony, Michelle, Chris, Isabella, and Andrew.

Much gratitude to the contributors: Katharine, Jack, Tessa, and Dominique.